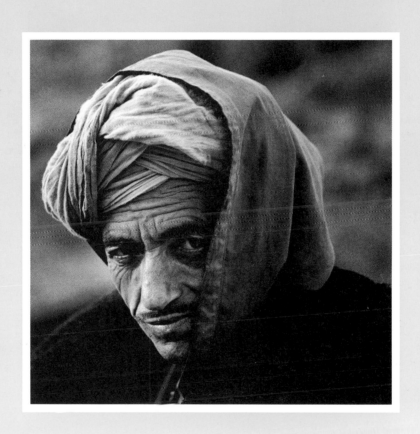

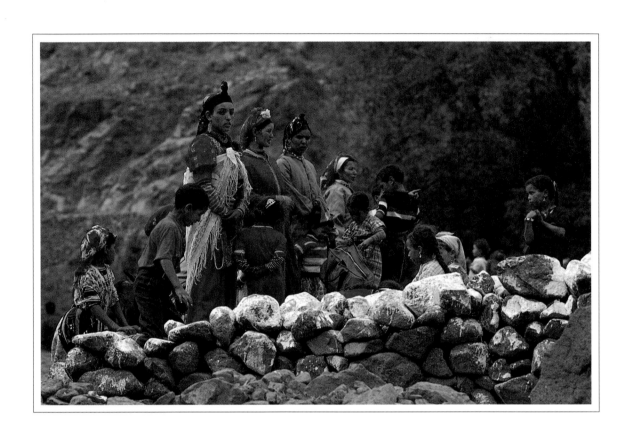

ALAN KEOHANE

The Berbers of Morocco

INTRODUCTION BY NICHOLAS SHAKESPEARE

HAMISH HAMILTON

HAMISH HAMILTON LTD

Published by the Penguin Group
Penguin Books Ltd, 27 Wrights Lane, London W8 5TZ, England
Viking Penguin, a division of Penguin Books USA Inc.
375 Hudson Street, New York, New York 10014, USA
Penguin Books Australia Ltd, Ringwood, Victoria, Australia
Penguin Books Canada Ltd, 2801 John Street, Markham, Ontario, Canada L3R 1B4
Penguin Books (NZ) Ltd, 182–190 Wairau Road, Auckland 10, New Zealand

Penguin Books Ltd, Registered Offices: Harmondsworth, Middlesex, England

First published 1991
1 3 5 7 9 10 8 6 4 2

Typeset in 11/13pt Linotype Postscript Garamond 3
Printed in Singapore by Toppan Printing Co Ltd

A CIP catalogue record for this book is available from the British Library

Library of Congress Catalog Card Number: 90–85831

ISBN 0-241-12966-4

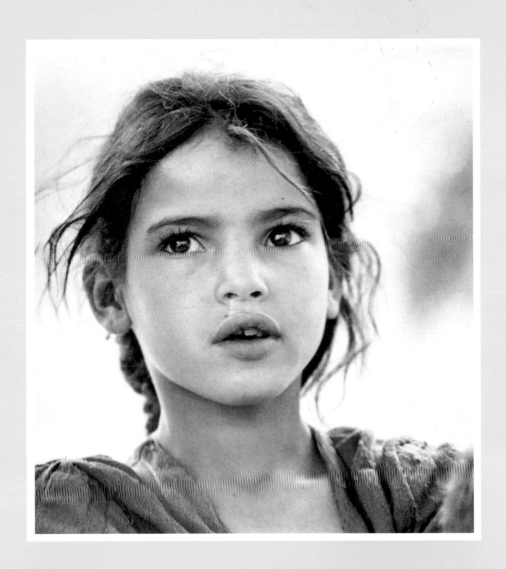

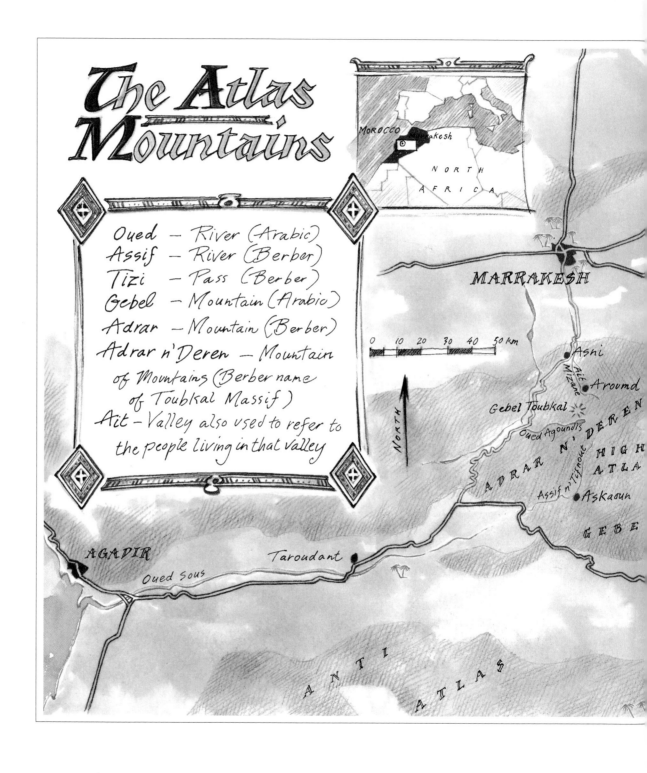

The Atlas Mountains

Oued — River (Arabic)
Assif — River (Berber)
Tizi — Pass (Berber)
Gebel — Mountain (Arabic)
Adrar — Mountain (Berber)
Adrar n'Deren — Mountain
of Mountains (Berber name
of Toubkal Massif)
Ait — Valley also used to refer to
the people living in that valley

MOROCCO

Marrakesh

NORTH AFRICA

0 10 20 30 40 50 km

MARRAKESH

NORTH

Ashi
Aït Mizane
Aroumd
Gebel Toubkal
Oued Agoundis
Assif n'Tifnout
Askaoun

ADRAR N'DEREN

HIGH ATLAS

GEBE

AGADIR
Oued Sous
Taroudant

ANTI ATLAS

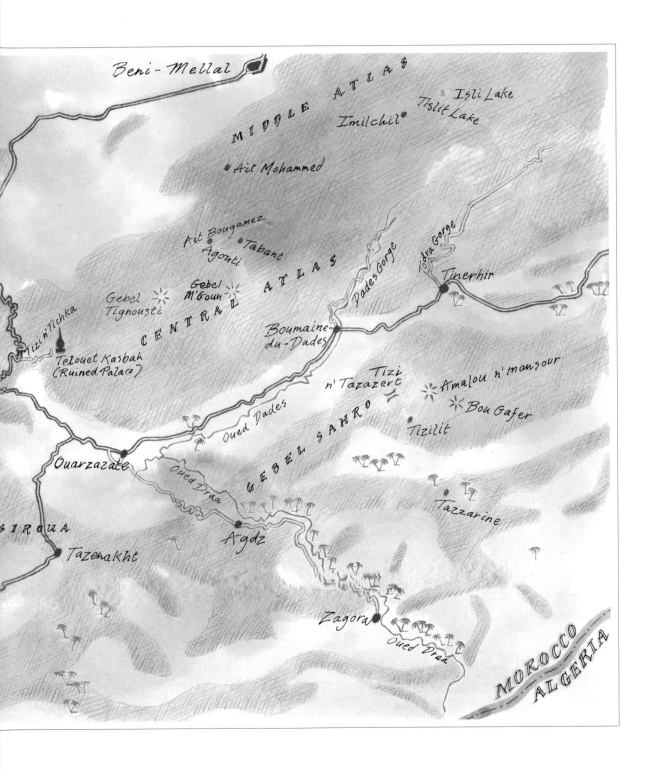

Beni-Mellal

MIDDLE ATLAS

Isli Lake
Tislit Lake
Imilchil

Ait Mohammed

Ait Bouganez
Agouti
Tabant

Todra Gorge

Dades Gorge

Tinerhir

Gebel
Tignousti

Gebel
M'Goun

CENTRAL ATLAS

Boumaine-
du-Dades

Tizi'n'Tichka

Telouet Kasbah
(Ruined Palace)

Tizi
n'Tazazert

Amalou n'mansour

Bou Gafer

Tizilit

Oued Dades

GEBEL SAHRO

Ouarzazate

Oued Draa

Tazzarine

SIROUA

Tazenakht

Agdz

Zagora

Oued Draa

MOROCCO
ALGERIA

Acknowledgements

No book is the creation of its author alone; rather it is a team effort involving editors, designers, production, rights and sales staff. Accordingly I happily acknowledge the contributions of Sophie, Wilf, Shona, Jane and Harriet. They have all had their part in forming this book and I thank them for it. Additionally I owe an especial thank you to Dieter and Andrew whose enthusiasm and belief in the photographs have transformed them from a scattered collection into the book you see.

Family and friends also play an important role in any project that takes years to complete. Without their loans and encouragement the photographs would never have been taken. I would like to acknowledge my debt to Alistair in Aberystwyth and the photography staff at the Central. Anything I may know about making pictures I owe to them.

Finally thanks to Exodus Expeditions for having given me the opportunity to spend so much time with the Berbers of Morocco, some of whom I am fortunate now to be able to count among my friends.

بسم الله الرحمن الرحيم

اهداء!

أهدي هذا الكتاب إلى أصدقائي البربريين، انا آمل بانني قد توصلت بعون الله الى شرح تام ووافي عن حضارة واصالة البربر في المغرب.

لقد قضيت سنوات في جبال الأطلس وجبل سهرو واستقبلت بحفاوة تامة من قبل البربريين حيث كانت معاملتهم لي بمنتهى الأدب والإخلاص والسذاجة.

اوجه شكري بصورة خاصة لكل من سهن إيد بليد وعائلته ومحمد يعقوبي، والبربريين بابيت آتا، كذلك لمحمد، وهناك الكثير الكثير من البربر الذين لا استطيع ذكر اسمائهم جميعاً. يكفي بان أقول بانني لم اصادف في اي رحلة من رحلاتي في العالم شعب سموح ومحبوب وكريم مثل شعب البربر.

انا آمل انشاء الله بان الصور الموجودة في كتابي هذا تؤدي المهمة التي من اجلها طبعت هذا الكتاب وهي شرح عن نمط حياة هذا الشعب.

واخيرا وليس آخرا داعيا من الله لكم الخير والازدهار.

وفقكم الله ورعاكم

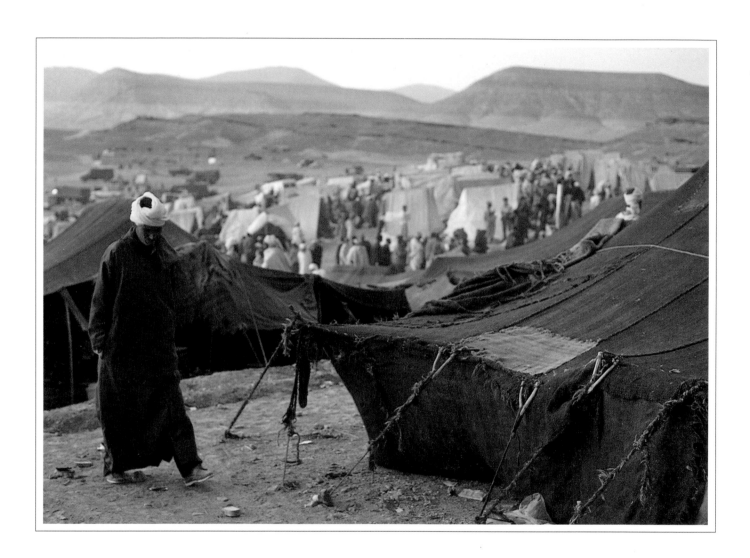

Introduction
by Nicholas Shakespeare

It is morning in September in the High Atlas and the hills are a tented city. It is the annual *moussem* of the Ait Haddidou and their tents – black, translucent, stretched from goat-hair that admits the light but keeps out the rain – crowd the tomb of a Berber holy man, Sidi Ahmed Oul-Maghanni, close to the village of Imilchil. The sun is rising, but already the market has the urgent seething of a city erected for only three days a year, before the snows come, smothering the valleys from October to March.

Families stock up on necklaces of doughnuts, cones of sugar in lavender paper, baseball caps saying 'Gibraltar', bellows, walnuts, cassettes. A boy blows into the ankle of a slaughtered goat, separating carcass from skin, which he then peels off like a gleaming wet vest. A story-teller – a midget in a yellow turban – prances to a *gimbri* violin. He speaks in a high-pitched voice. He tells of the death of Mohammed. He tells of a quack doctor boarding the bus to Imilchil, with unguents to cure you of everything. He tells of his Berber forebears.

The Berbers, the fair-skinned race of North Africa, were among the first inhabitants of Morocco. Today they account for over half the population. They maintain their own language, their own traditions, their own idiosyncratic sense of history. But no one knows with any degree of certainty who they are and where they came from.

With few exceptions, such as the fourteenth-century chronicle of Ibn Khaldun, Berber history is not written. There is virtually no Berber literature. When it comes to discussing the origins of the Berbers, everything remains speculative. The sources are laconic, the myths as distorted as the story-teller's squeaky vision of, say, the first Phoenicians to land in North Africa. The approximate date is 1200 BC. The Phoenicians are seeking new purples, new metals. They row to the peep of a flute. In the argan trees beyond the sand they find a race who worship the sun and sacrifice to the moon. Later they conquer them, the first of five invasions to be endured by the people we have come to know as Berbers.

It is thought that the Numidians were Berbers, also the Autoloti of Ptolemy and the Getulians of Hanno and the Troglodytes and Libyans of Herodotus. Goliath was a Berber and the Emperor Septimius Severus, who died in York in AD 211, and St Augustine's mother, Monica, and Tarik, who gave his name to Gibraltar. There is as much dispute over their name as their origin. Gibbon derives them from the Greek word for outcast; others speak of Berbers as the original Barbarians; Ibn Khaldun describes them as people from the land of Ber (son of Ham). 'They belong to a powerful, formidable, brave and numerous people; a true people like so many others the world has seen – like the Arabs, the Persians, the Greeks and the Romans.' To Leo Africanus, three hundred years later, they were 'the greatest thieves and traitors and assassins in the world'.

Others speak of a migration to Morocco after a Berber girl's dress was raised by the wind in front of a king who laughed: in shame at their misfortune the tribe left that night. They are descended from the aboriginal Cro-Magnonolds of Upper Paleolithic Europe, say others; from nomadic Mouillian hunters, whose origins reach back to 10,000 BC; from sedentary farmers, never reconciling the two ways of life. No one really knows anything. But in their long roll down the escarpment of history they have carried their contradictions with them: there are Berbers who wear veils, and Berbers who do not; there are Berbers – the majority – inhabiting the mountains who do not understand the language of those Berbers who live in the desert; there are nomads and semi-nomads and static pastoralists – all contradictions which have prevented the formation of a Berber state (except a brief republic of the Rif in the 1920s).

The Phoenicians who traded their trifles for ivory and gold and ostrich eggs semi-subjugated the Berbers for a thousand years. After the Phoenicians they were washed over and polished in turn by the Romans, the Vandals, the Arabs and the French. But whether his governor was Phoenician or French, the Berber never gave more than a part of himself. He wore rather shabbily the remnants of each passing invader. He half digested their customs. Beneath the lacquer, he remained his parochial self, paying as much lip-service to Islam as he had paid to Christianity (and apostatizing twelve times in seventy years, according to Ibn Khaldun). The Berbers' ability to endure can be ascribed to the deeply conservative nature of their identity: travellers returning to the Rif as recently as 1928 hesitated to tell of what they had seen in case they were branded as liars. Partly, too, it can be explained by what the French writer Robert Montagne describes as the most characteristic aspect of the race – 'his lack of imagination and his relative poverty' – which no doubt also explains the Berbers' nostalgia and respect for only the most dimly understood customs. Mostly it stems from what Walter Harris calls 'their deep-rooted and innate detestation of all authority outside that exercised by their own democratic and local organizations' – in other words, their love of independence.

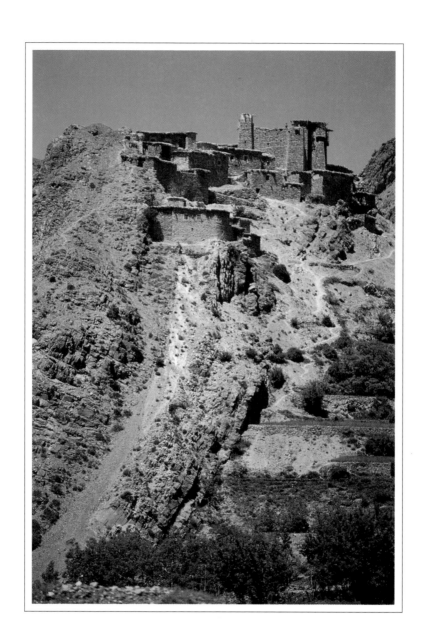

Like the Kurds, the Berbers are a people without a state. Like the Scots, with whom they share a clannish system of tribes (*Ait* means people of), the Berbers are natural rebels quite as much as they are unnatural rulers. 'The whole life in those great Atlas fortified *kasbahs*,' wrote Walter Harris, 'was one of warfare and of gloom. Every tribe had its enemies, every family had its blood-feuds and every man his would-be murderer.' They have fought everyone. In 950 BC the Berbers were fighting the Pharaohs on the Nile. In AD 711 they formed the vanguard of Tarik's army in Spain (where they remained for 700 years, bringing back with them their blue Iberian eyes). Most of all, they have fought themselves. It is hardly surprising to discover that almost every general implicated in the attempted coup of 1971 was a Berber.

They call themselves Imazigher, the free, and they fiercely protected this freedom, none more so than their women. The power of these women led F. R. Rodd in his classic *People of the Veil* to describe the desert Berbers before the Arab invasion as having 'a completely matriarchal organization'.

Berber women were very probably the Amazons of Diodorus Siculus. They mutilated prisoners, they hennaed any man who showed his cowardice and they led their men to war. They were still leading them there a hundred years ago – the prophetess Lalla Fatima was finally defeated in the Kabylie mountains by an army of 30,000.

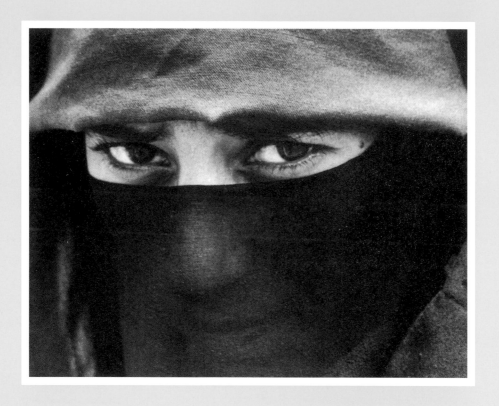

Among the Berber women were Barshako, who dressed as a man, led several camel-pinching raids and returned home to resume her quiet place in the kitchen, eventually advising her poor husband to marry someone else; and the most famous and savage of the lot, Kahena, the Veiled Queen of Jerawa, who galloped her men against the Arabs during a five-year insurrection. A lament describes her thus:

More cruel than all the others combined
She gave our virgins to her warriors
She washed her feet in the blood of our children.

Kahena died in battle in AD 702, riding out against the Islamic invader, her breasts sore from the night before when she had smeared them with farina and oil and ordered her three sons to suckle her. Weaned on such women, the Berbers experienced little trouble in keeping their freedom. Until 1933 no outside government had ever gained authority over the Berber tribes of the High Atlas. The most independent of these, the tribe that resisted the longest (chanting 'we are going to die' as it hurled itself against the French), was the Ait Haddidou.

The story-teller prances. In his high-pitched voice, to the monotonous grazing of his *gimbri*, he tells the story of two small lakes, Isli and Tislit, named after a couple in love who bathed in milk and were punished by God. His voice lifts over the tents of the *moussem*.

The three day *moussem* of the Ait Haddidou illustrates the Berber's capacity to absorb and reject and endure. Beneath the tents, pagan, Christian and Islamic elements combine and spar.

At its most elementary it is a market for provisions, for camels, for clothes, held each year as the semi-nomadic tribe migrates to lowland southern pastures. It is held according to the moon (which must come up the right way or else the *moussem* is delayed). The jewellery laid out for sale includes silver amulets engraved with the Phoenician sign of Tanit, or phalluses against the evil eye (*al-ain*). The sweet mint tea – 'whisky Berbère' is poured high from the camel-nozzle spouts of teapots originally manufactured in Manchester by a man called Wright (whose name has drifted into the language to describe anything silver). The local saint, whose tomb is the focal point, has the power to bestow fertility. He bestows it on those couples who have come here to marry. Far more important than the purchase of sugar and Gibraltar caps and sand-coloured camels, the *moussem* is a market to celebrate marriage, to secure the future of the tribe.

The Ait Haddidou marry within themselves. Outsiders are Rumi, derived from the Romans who never penetrated this far south. If a woman sees a monkey or a Christian, goes a Berber saying, she must avoid intercourse that night in case her offspring resemble either. The virgin brides wear a flat-topped head-dress. Their cheeks are rouged with honey and coral cochineal to keep away evil spirits. Their eyebrows are arched with soot and spittle, their chins tattooed with indigo or gunpowder, which has been worked into the skin with needles and rubbed over with bean leaves. Their presence on the orange carpet before the notary is a matter of legal compliance, not tribal tradition – to fulfil the registration demanded first by the French and then, following independence, by the Moroccan government. The actual marriage will take place after the harvest. There will be a mock fight between members of the two families. The bride will ride a donkey to the groom's house, a slaughtered lamb for saddle. Her mother-in-law will carry her over the threshold. And that night, as the Berbers have it, she will be broken like a cane.

But more significant even than the marriage ceremony is the function of the *moussem* as a meeting-place for divorced men and women. In their matrilineal independence, the women are far removed from the constricts of Islam. They can choose to divorce. They can retain their dowry. They can marry as many times as they wish, returning each year in their pointed hoods (their hair bolstered by dyed wool and twisted with a lump of salt) to choose a new husband in the lanes between the tents.

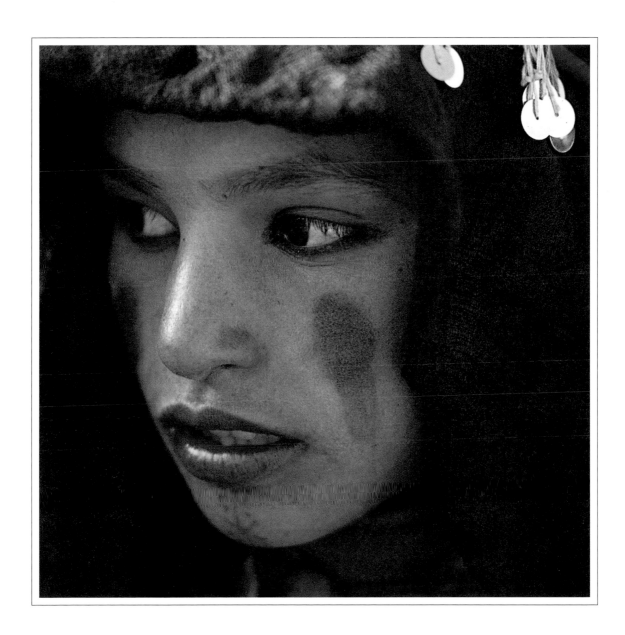

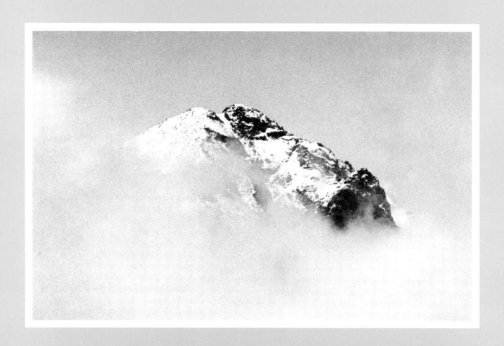

Until this century few Europeans had penetrated the Berber tribes of Morocco. Until 1920 no European had entered the Jibala mountains of the north-west, whose peaks were visible from Gibraltar. When Walter Harris entered Chaouen he found the Berbers using the calligraphy of fifteenth-century Andalusia. Of the mores, superstitions and customs of this tribe, France's Lieutenant-Colonel Henrys admitted in a report that what was known was 'very little, if not nothing'. All the more, then, should we be grateful to Alan Keohane for returning with a photographic testimony which manages both to explain and to preserve the mysterious, irreducible essence of this people.

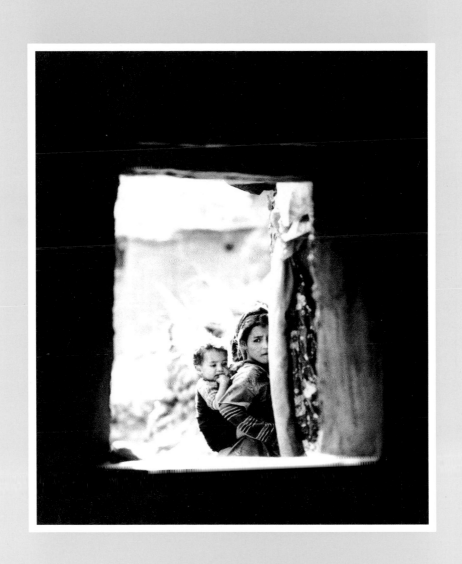

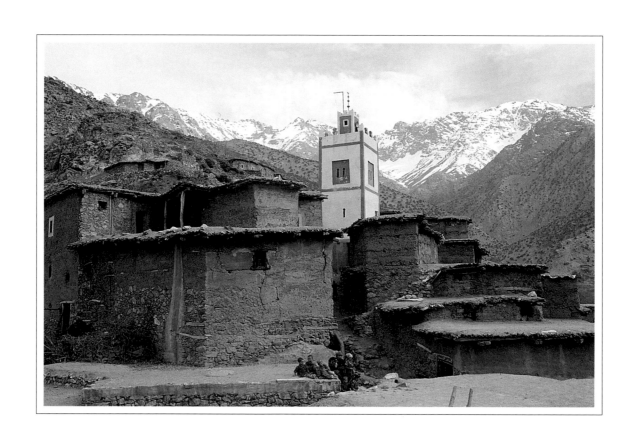

The Berbers of Morocco

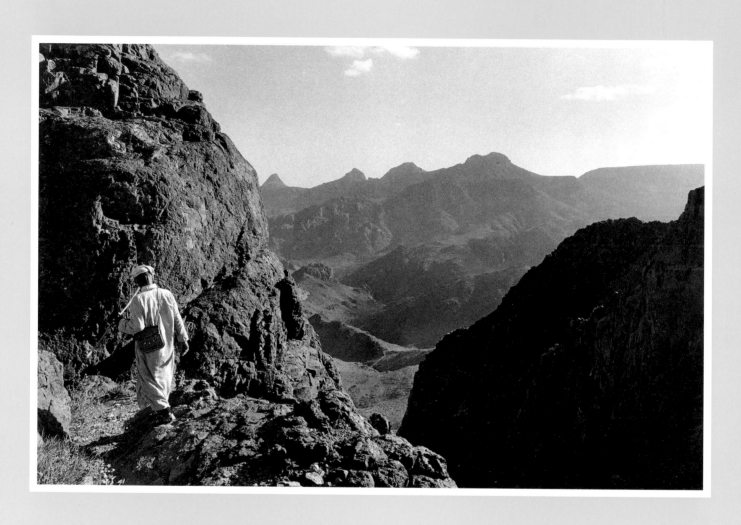

The Gebel Sahro, an outlying mountain range of the High Atlas, is a rugged, dry region inhabited mostly by nomadic herders of the Ait Atta tribe.

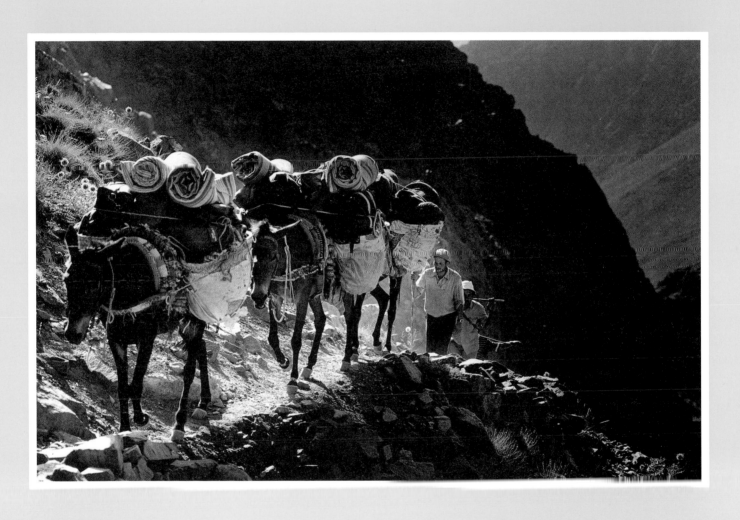

Travel along the ancient paths and tracks connecting villages and valleys is on foot or by mule.

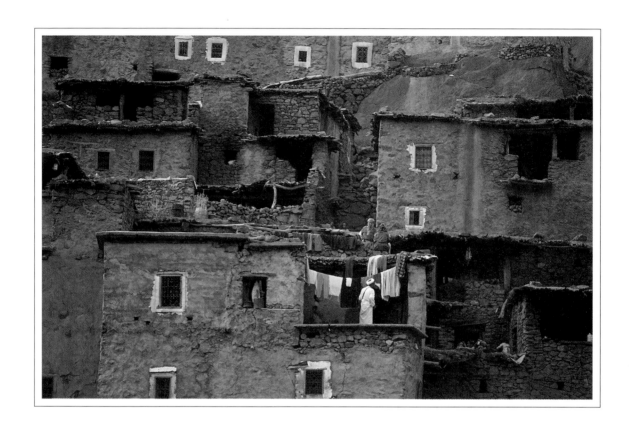

Aroumd is the highest village in the Ait Mizane valley. A jumble of houses are built one upon the other on the steep mountain-sides.

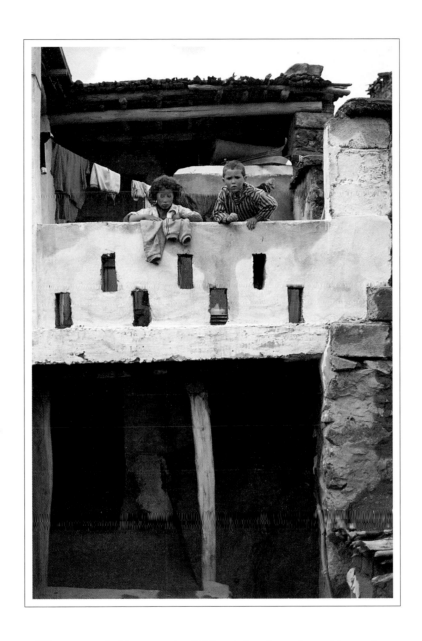

The western clothing worn by children is bought at the weekly markets.

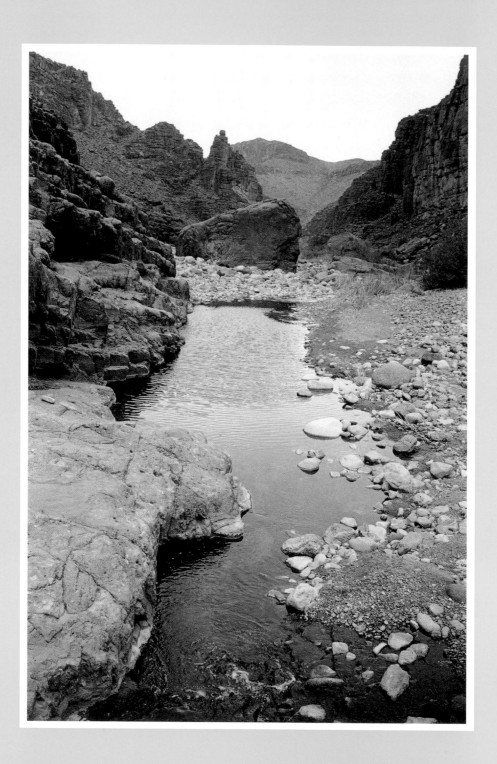

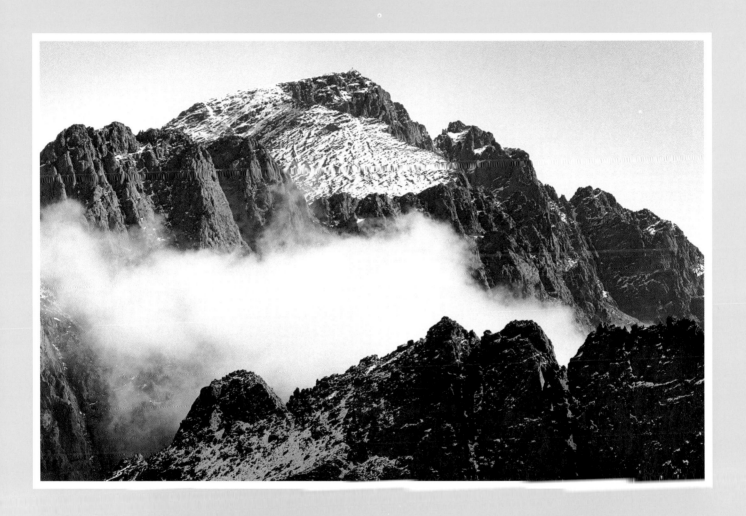

Toubkal – the highest mountain in North Africa – is called adrar n'deren, *or mountain of mountains, in the Berber language. In the mountains of the arid south, precious water flows in a few of the valley beds, providing remote farms and wandering goatherds with the opportunity to survive.*

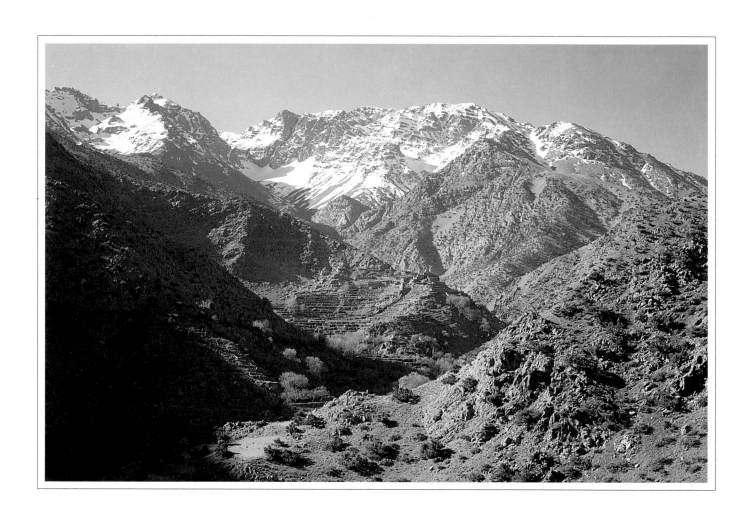

In winter the mountain villages are often cut off by heavy snowfalls and landslides. Life becomes a bitter struggle against the ferocious cold, and families congregate in smoky kitchens, wrapped in blankets and woven woollen cloaks. There is little work for the men who, where possible, descend to the towns in search of temporary jobs.

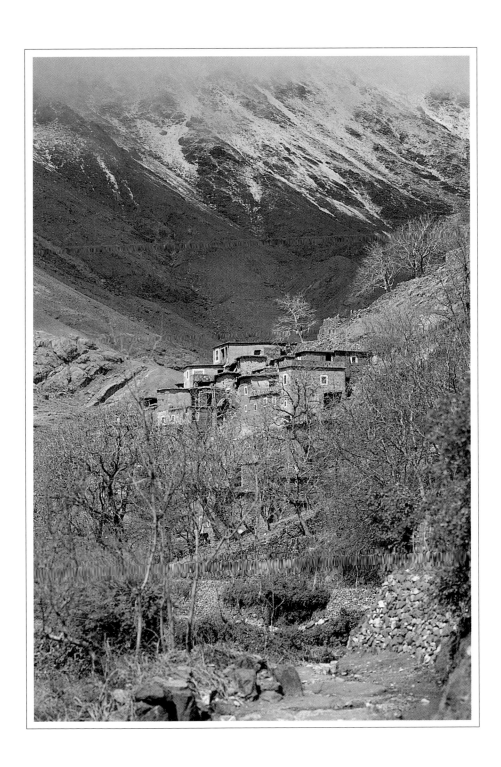

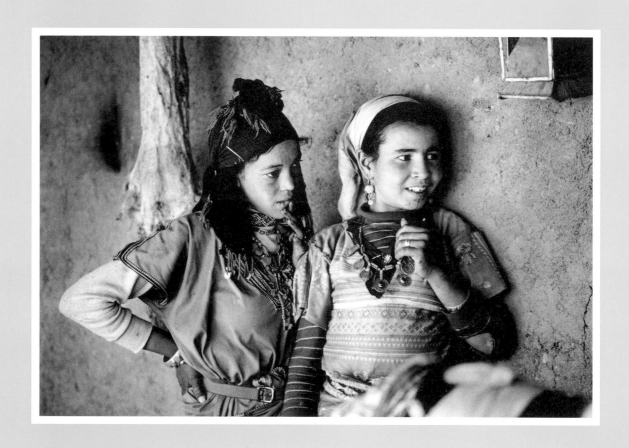

Traditional Berber jewellery (or schlurr*) made from coins and silver chains is favoured as everyday wear by women and girls from the Southern Atlas. In other areas, coloured beads, filigree and plastic jewellery have become very popular.*

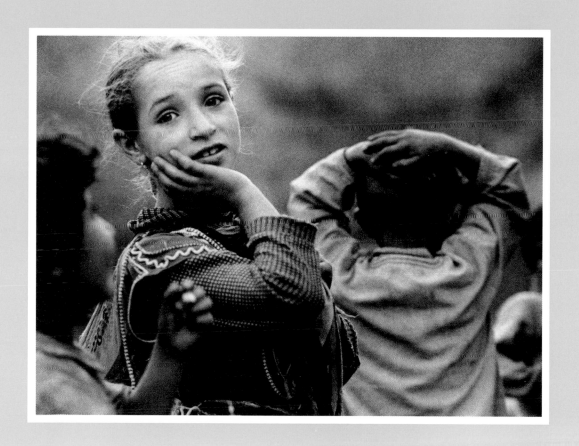

Since cash has become more important in the Berber economy, families often sell the valuable wool from their sheep and buy cheaper nylon clothing for women and children instead.

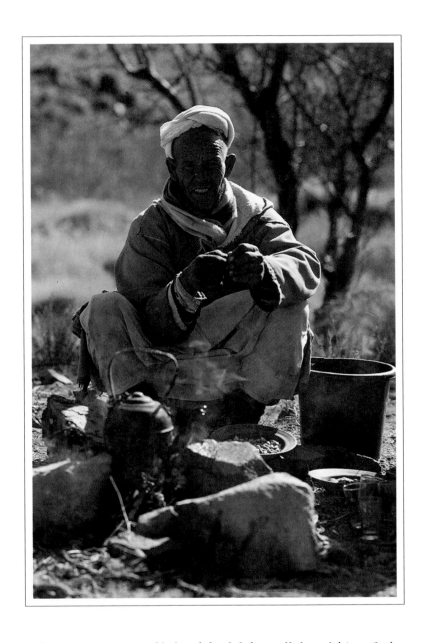

Berber men wear an ankle-length hooded shirt called a gelabiya. *Cool cotton in summer is replaced by heavy wool in the colder months. Southern nomads, like this member of the Ait Atta, wear small turbans that can be used to cover their mouths for protection against the dust.*

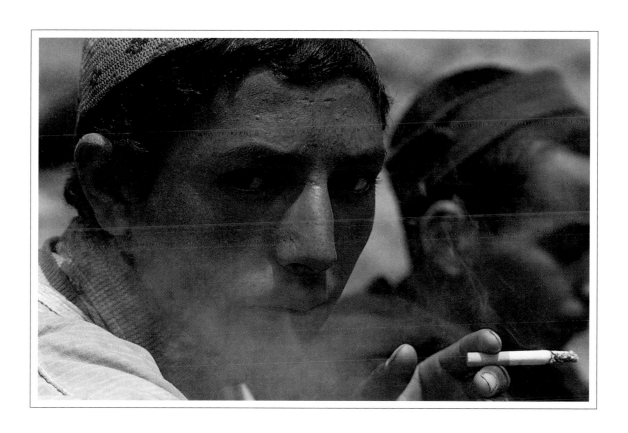

Men of the High Atlas tend to wear crocheted skullcaps; small turbans are worn only on special occasions.

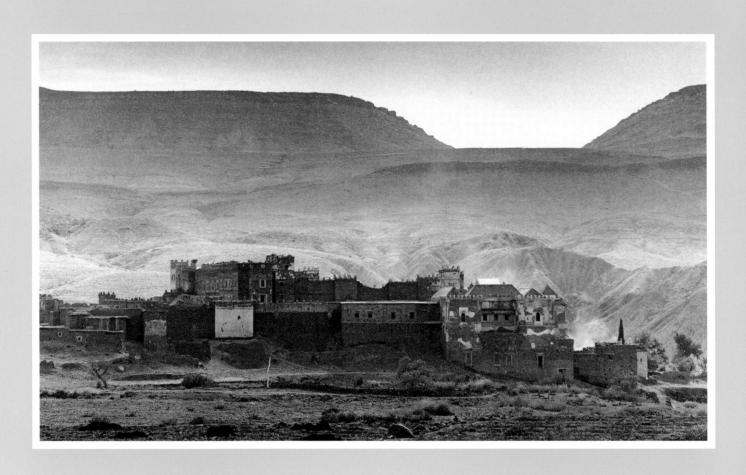

The Palace of Telouet, traditional home of the powerful Glouwia clan. It is an ancient site built on the ruins of older palaces and, though some rooms are still used by the local governor, it is now mainly derelict.

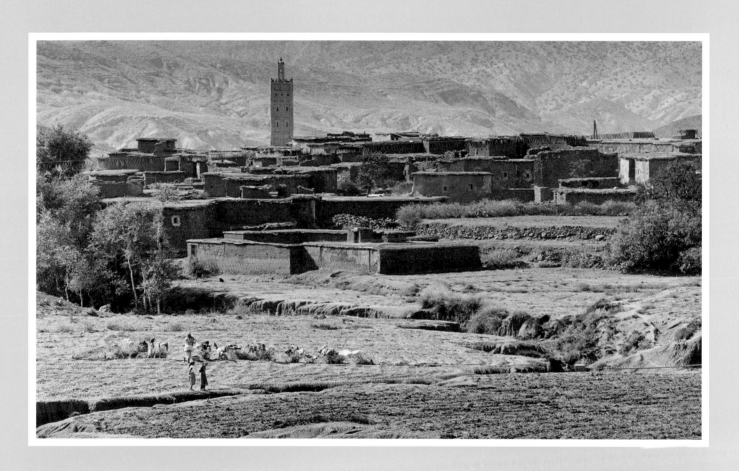

The village of Telouet.

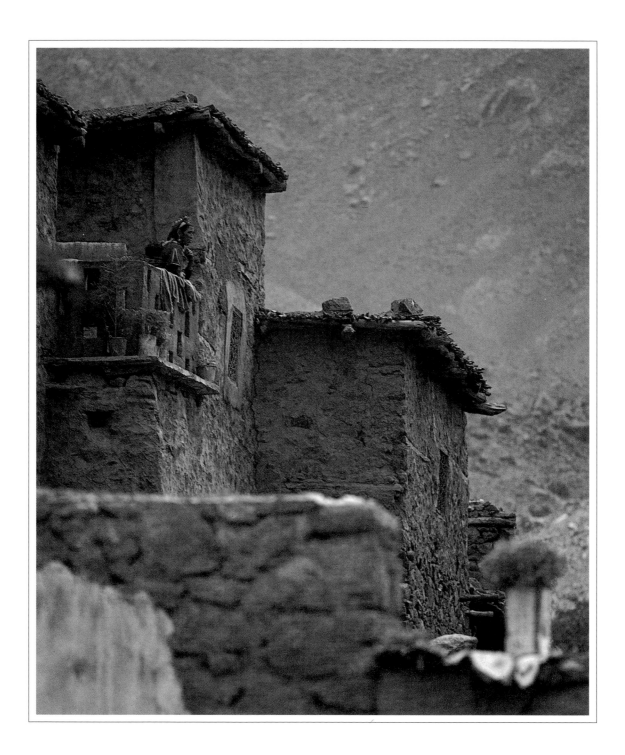

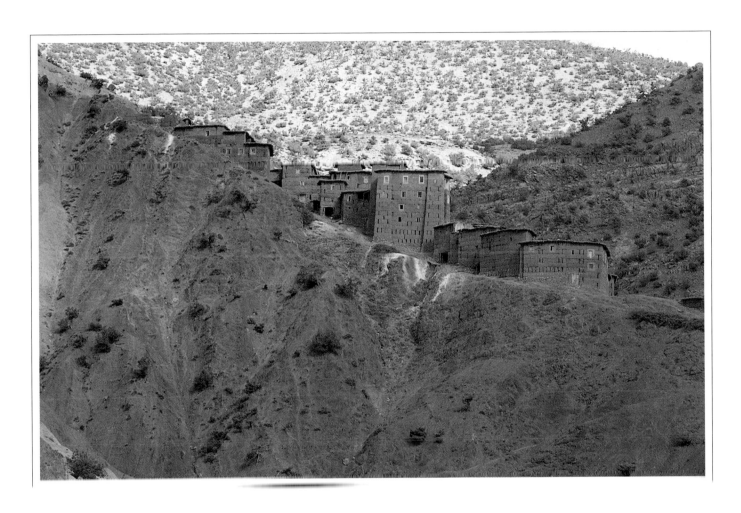

There are distinct differences in architecture between the houses of the north and those of the south. On the more craggy northern slopes, houses are small, densely packed and built of stone. On the more arid southern side of the mountains, huge buildings are constructed from adobe.

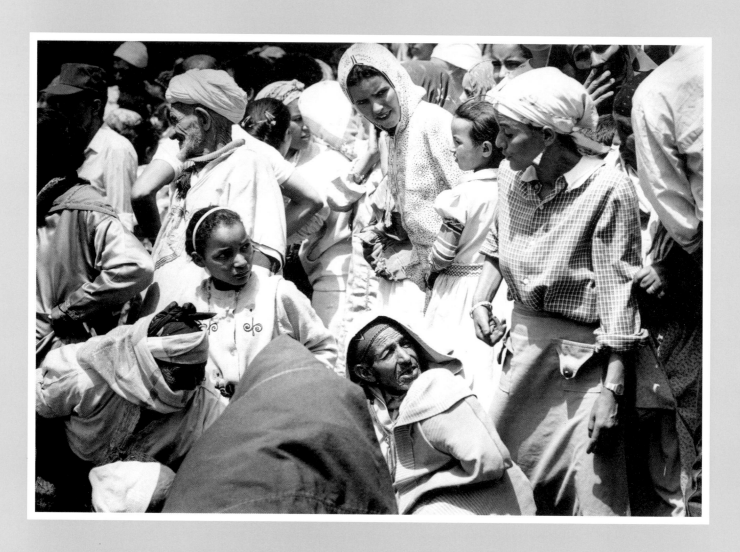

The crowd awaits the sacrifice of a bull at a local festival or moussem. *There is no segregation of the sexes on such an occasion.*

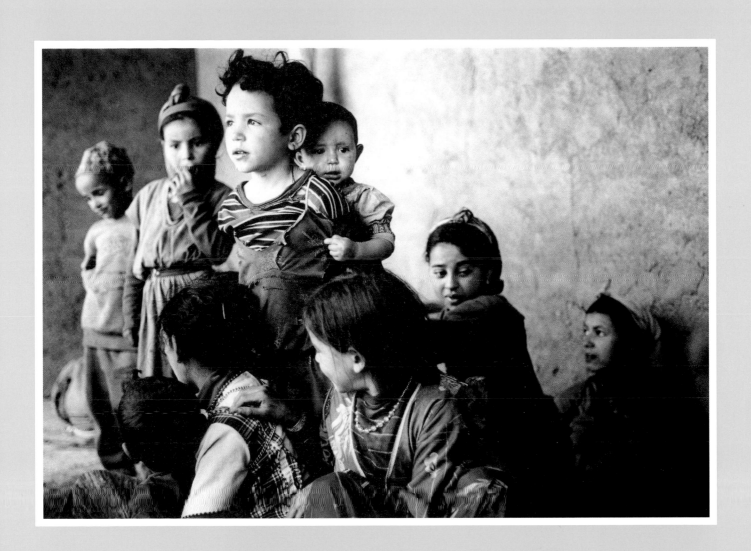

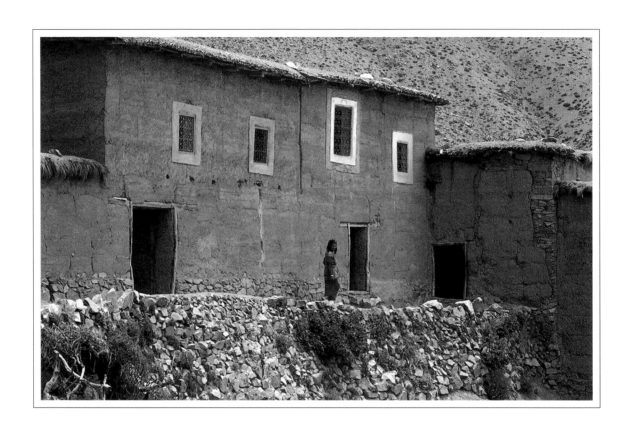

Andous village in the Southern Atlas. Ornate metal grilles are commonly used in windows.
Glass is rarely seen.

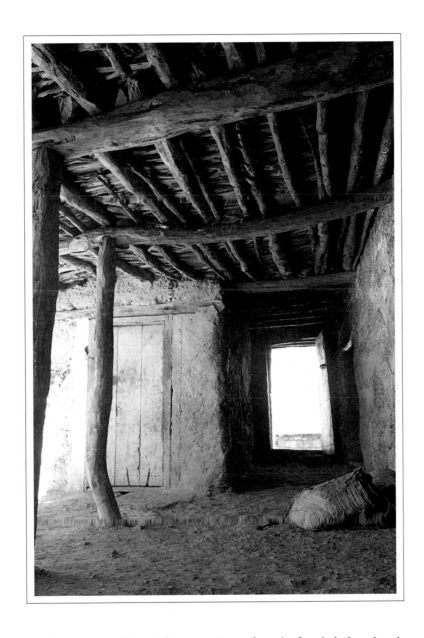

Red juniper wood is used for supporting roofs made of sunbaked mud and straw. After heavy rains these are prone to collapse.

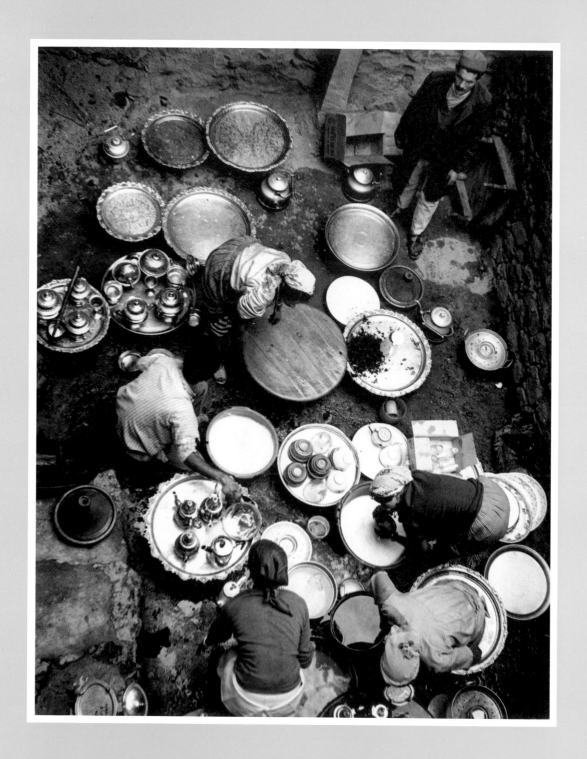

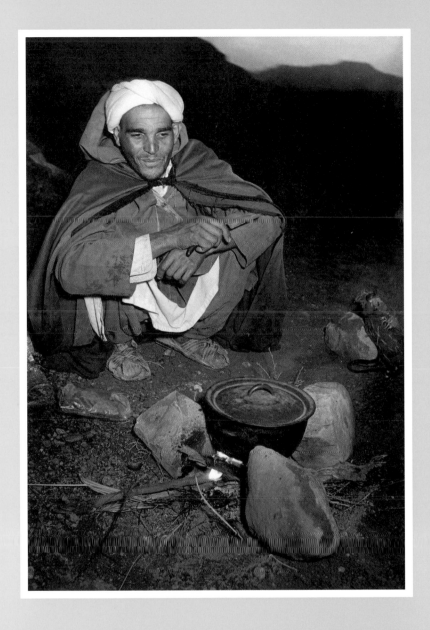

Mint tea (called atai) *is central to the tradition of hospitality among the Berbers, and wealth and status are represented by a family's tea-sets. The family shown opposite is very wealthy and owns seven or more silver and brass tea-sets. In contrast to the villagers, the minimalist nomads must be able to pack all their belongings on to the back of a mule.*

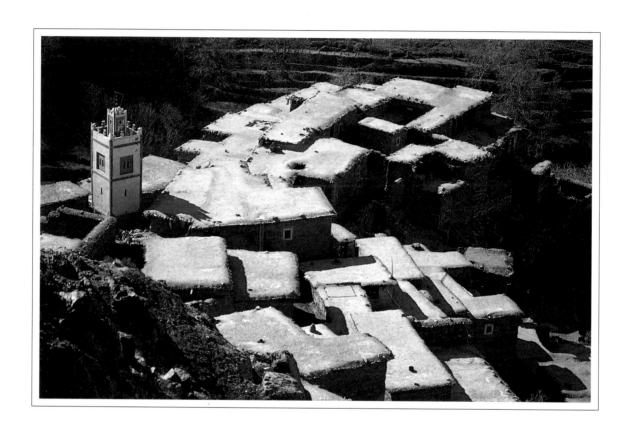

Tizi Oussem, showing the flat roofs which double as other people's balconies. Villages are built into the mountain-sides to leave the fertile valley bottoms free for cultivation.

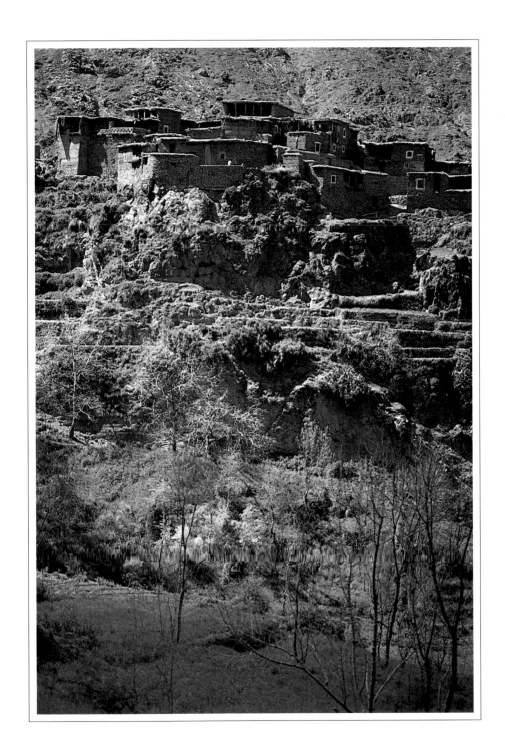

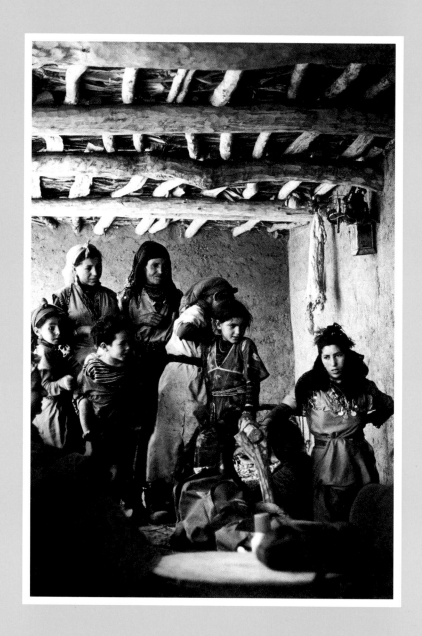

Women and children of the Tifnout Berbers.

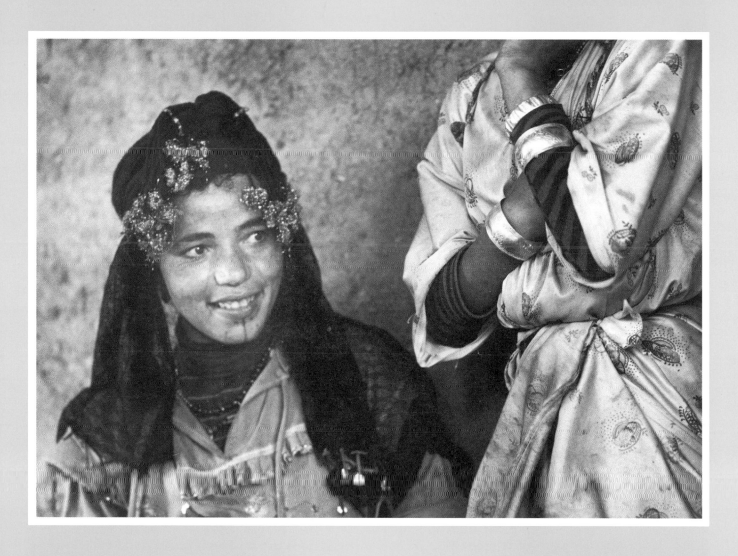

*Women living on the dry, desolate southern side of the Atlas seem to make a conscious effort
to wear more decorative clothing and jewellery. Tattooed faces are common. As a woman
gets older, the tattoos are made more elaborate.*

Using yarn from their own sheep or dyed wool from Marrakesh, Berber women make their own rugs, and cloaks and gelabiyas *for their menfolk. There is no tradition of knitting, as the hand-spun yarn is too weak.*

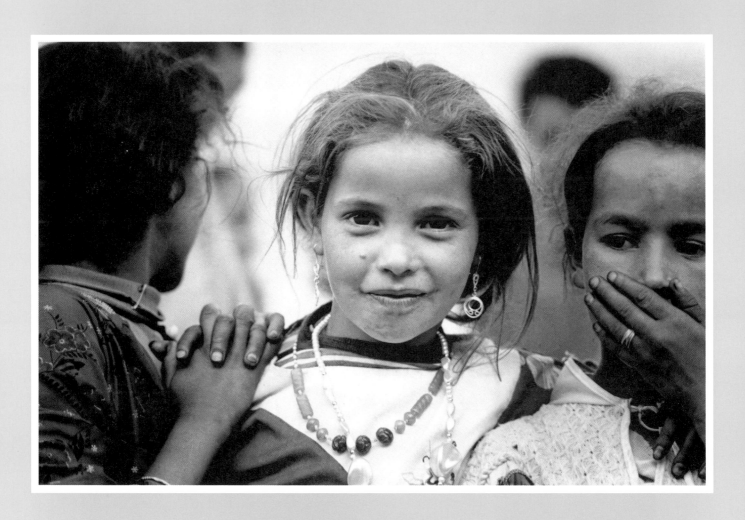

Girls of the Ait Mizane.

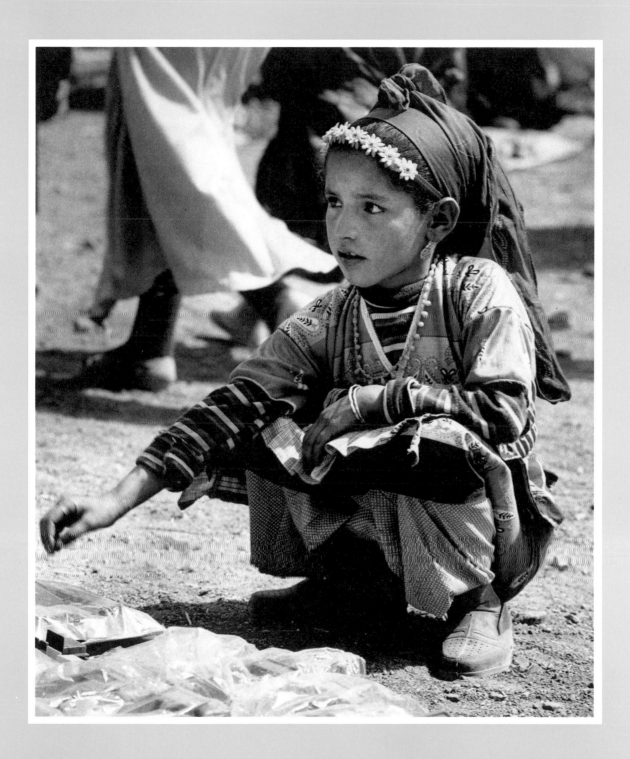

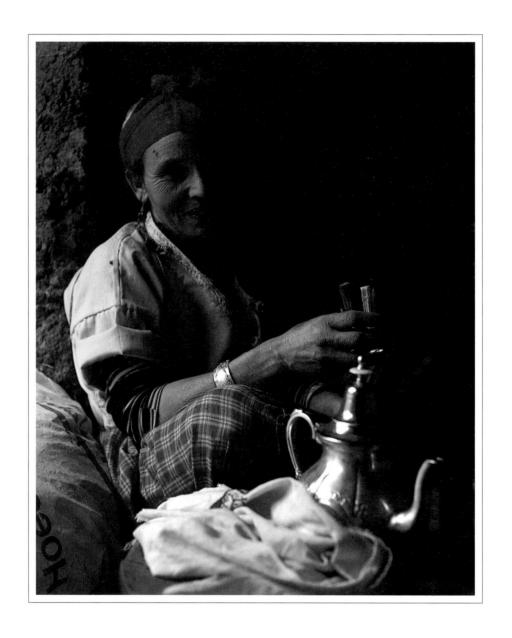

Aisha is a widow and therefore head of her household. In the absence of a husband, she entertains any male visitors.

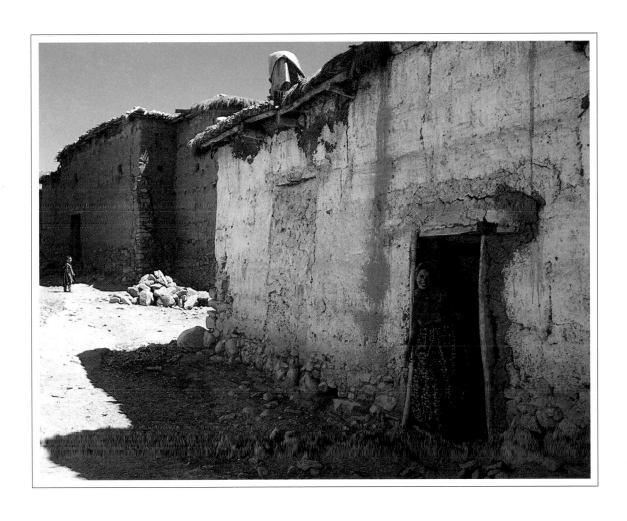

A southern village in the Tifnout. The houses are organic and change frequently: a door is blocked off and replaced, or a window moved.

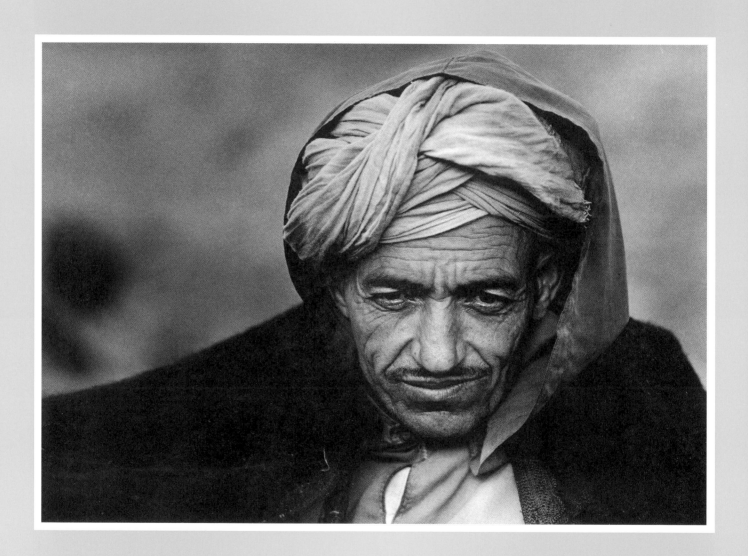

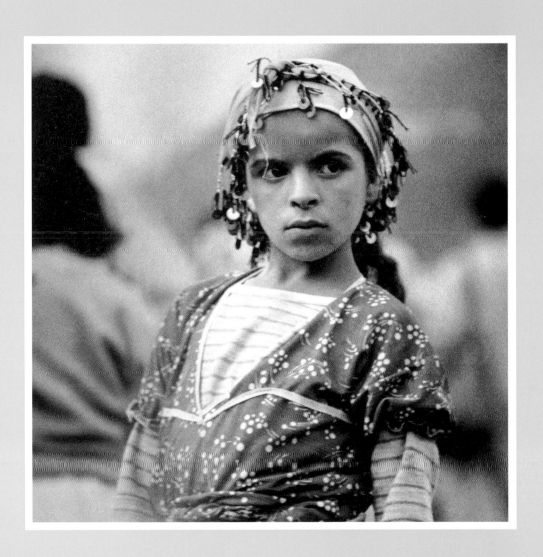

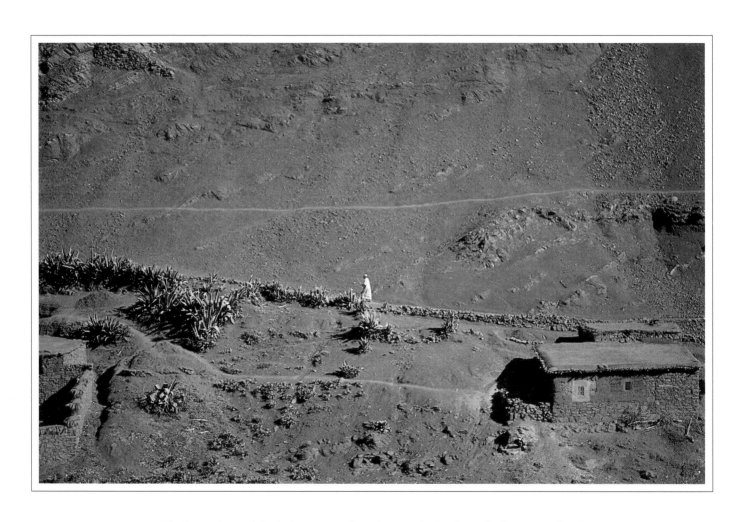

The lower slopes of the Atlas consist of sandstone, which colours the houses a rich red.

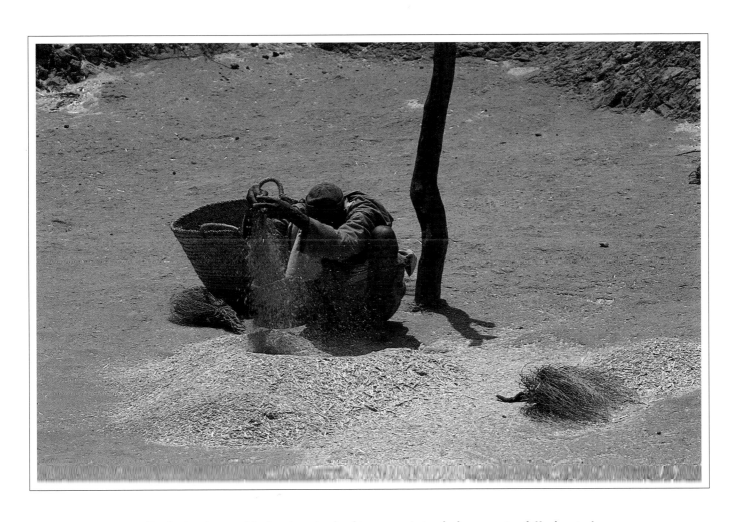

Barley is winnowed by hand on the threshing ground. As the heavy grains fall, the wind blows the lighter chaff to one side.

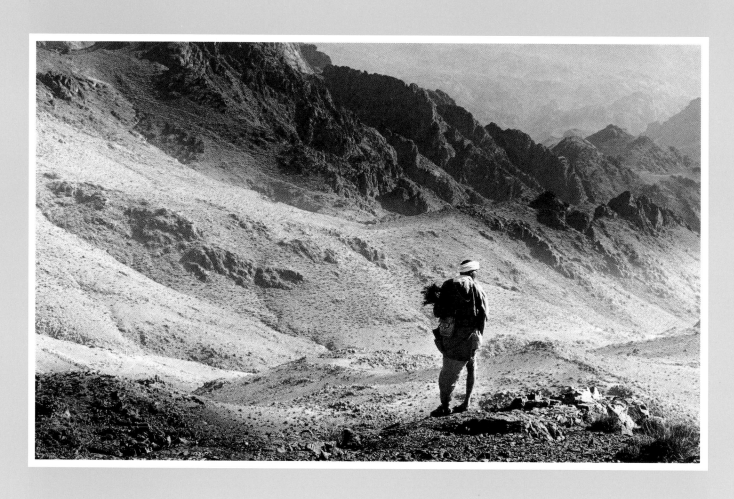

Collecting firewood in the Gebel Sahro.

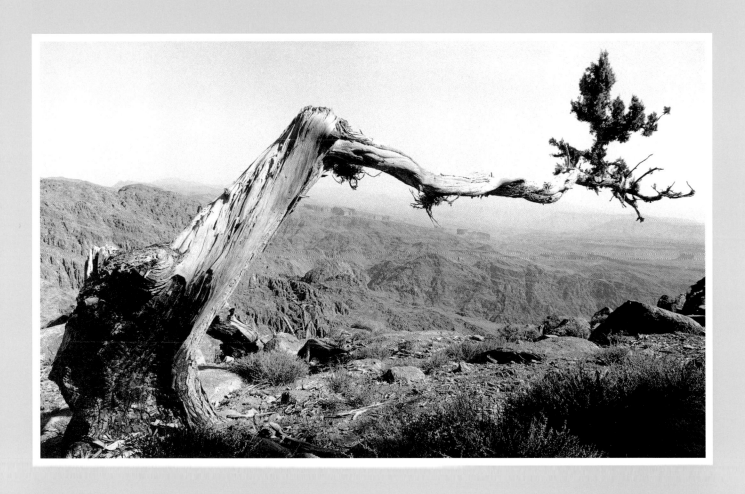

Juniper forests once covered much of the Atlas. Their disappearance is due mainly to overgrazing and the need for firewood.

The Ait Bougamez, the main valley of the central Atlas. Its population is relatively wealthy, living off large areas of richly cultivated land.

The Tifnout flows south from Toubkal. Its waters provide irrigation within the gorge-like valley.

The Draa valley runs south from the High Atlas into the desert, supporting oases and providing pasture for the nomads in winter when the mountains are snowbound.

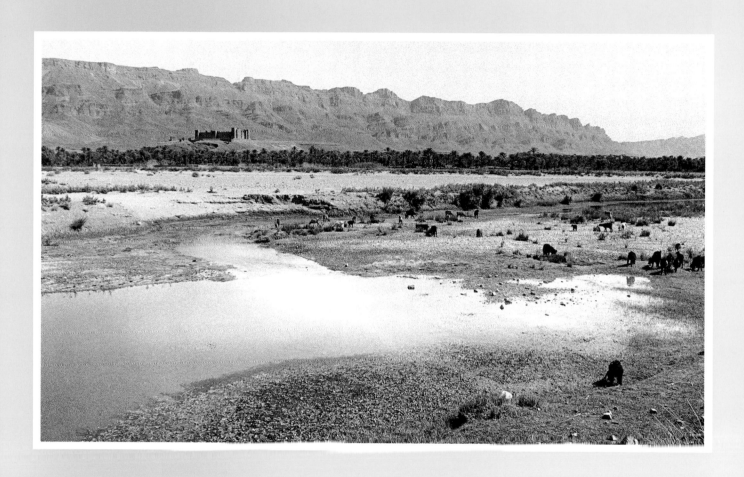

The Draa flows past a kasbah *– an ancient fortified granary or village.*

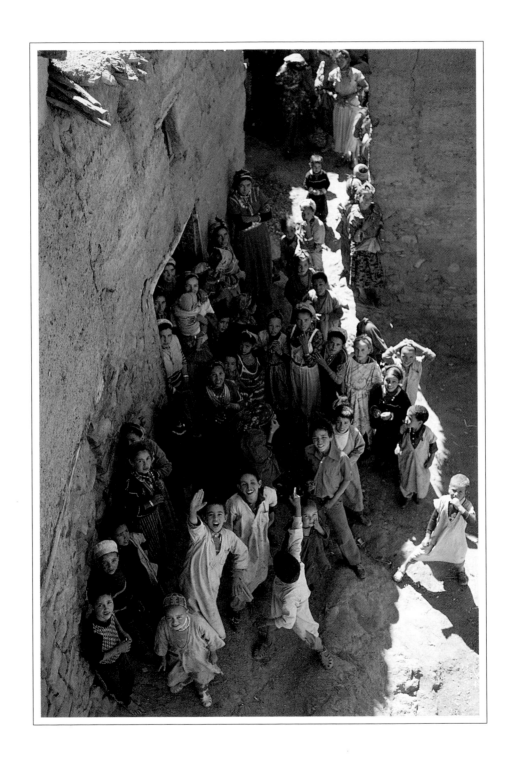

A Berber festival

The festival, or *moussem*, is an important feature of Berber life and is usually held towards the end of the summer. The *moussem* of Sidi Chamarouch is, for the Ait Mizane, the occasion for a great gathering of the tribe and its clans. Sidi Chamarouch is a well-known figure in Morocco, and is commonly believed to be the King of the Devils and to hold the power over spirits possessing people. The Ait Mizane believe he was a sixteenth-century madman who stayed with a family in the village of Aroumd; the head of the family today acts as guardian to the shrine.

The festival begins with the arrival of local salesmen, who set up their small tents in the village square in preparation for the many hundreds of people who will arrive for the main events on the third day. Story-tellers and fair people also arrive, travelling on foot, by mule and, more recently, by market trucks along the track built in 1988.

By the second day, the valley is full of families camping out in the meadows and the square becomes a jumble of tents and fairground stalls. Within the market, traders sell clothing and trinkets, cafés provide gallons of mint tea and soft drinks, and doughnut-makers, having constructed their ovens from mud and stones, sell fresh pastries by the kilo.

On the big day, all the Berbers from the neighbouring settlements are present. Some have stayed overnight, others have walked from their homes that morning. The valley is full and there is little room to move in the village square. The festivities begin with a feast for local government officials from the regional centre, and a formal dance in their honour. Then the sacrifice of a mature bull in the spirit of the King of the Devils is made. The rooftops are a mass of chanting Berbers, and the excitement of the crowd reaches a frenzy. It is believed that, while the animal is still alive, the blood of the offering helps to cure people possessed by devils. As it thrashes and staggers, those touched by devils respond with uncontrollable fits of shouting and wailing.

The Berbers have incorporated pre-Islamic beliefs and ancient saintly cults into their religion, creating a unique branch of Islam.

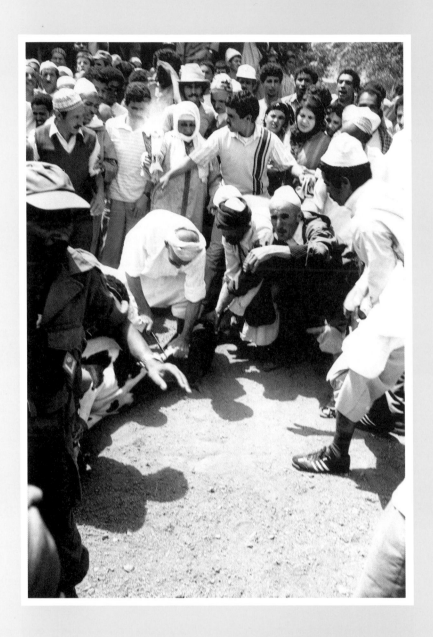

Hadjj Mohammed, head of the Ait Belaid family, cuts the bull's throat.

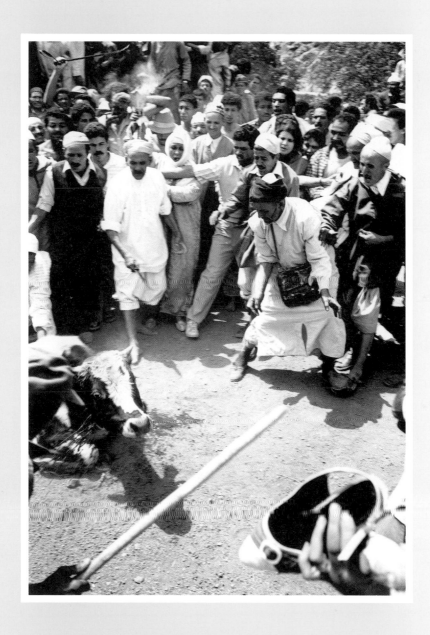

Mass hysteria as the animal dies.

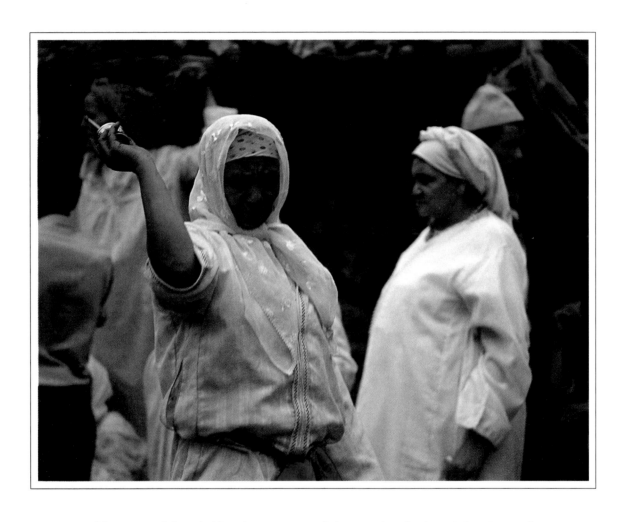

Older women of the tribe bless the spectators and the ground with cologne before the sacrifice is made.

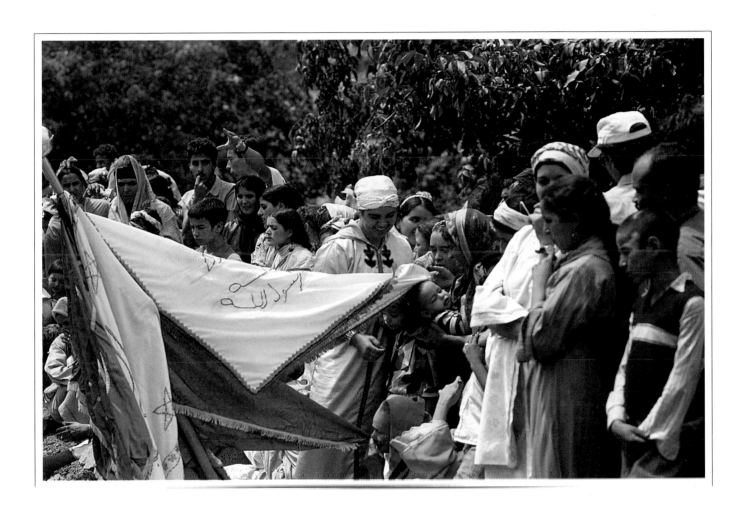

Flags inscribed with the holy words of the Koran are believed to have magical powers.

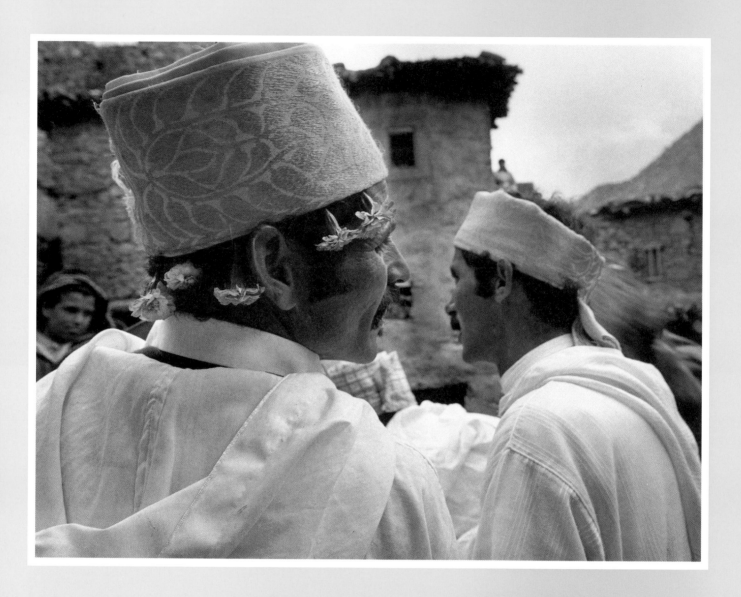

Men are dressed in their best clothes: gelabiyas *made of undyed linen and embroidered turbans decorated with flowers. On the afternoons of the* moussem, *the men begin the dancing and singing.*

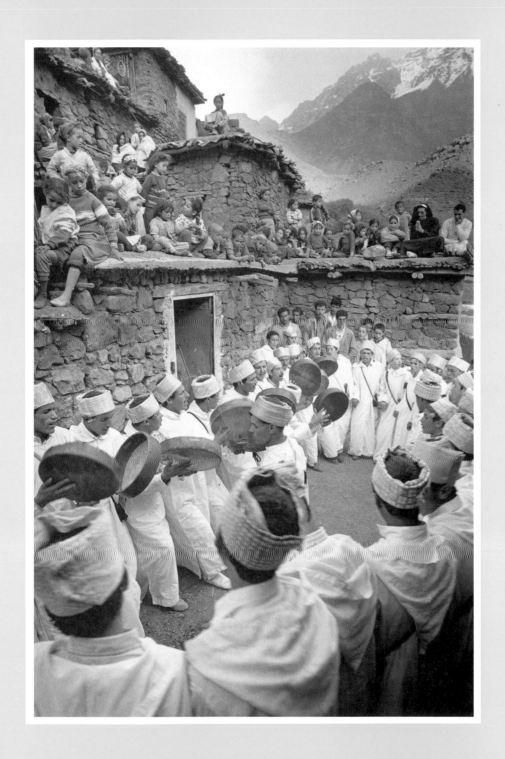

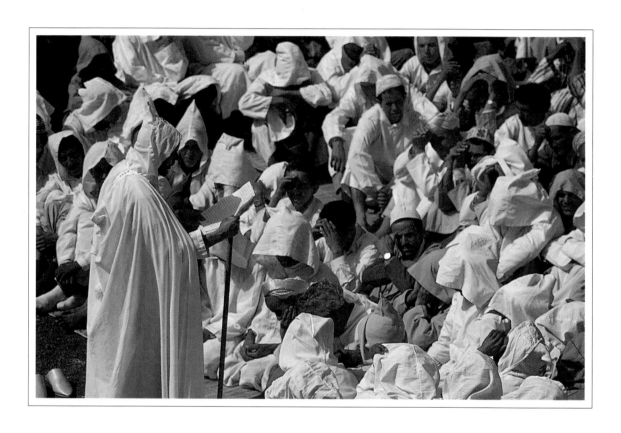

Central to many festivals is a religious procession headed by the imam *(the leader of prayers in the mosque). The men of the village process around the fields accompanied by singing women, and stop for communal prayers and a recital of the village history.*

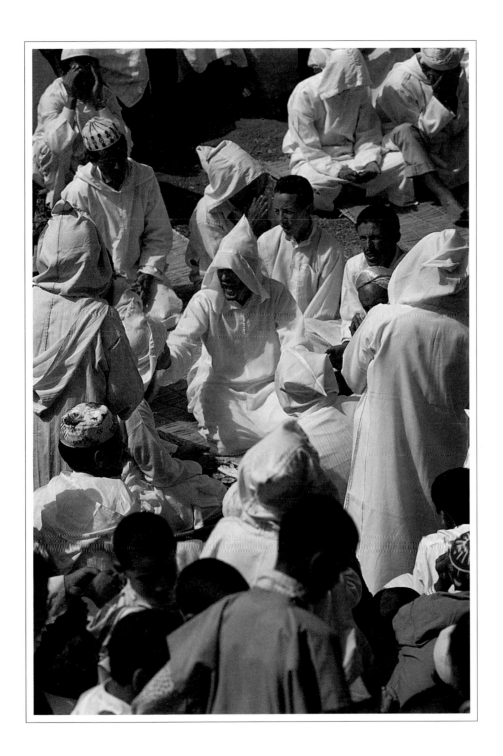

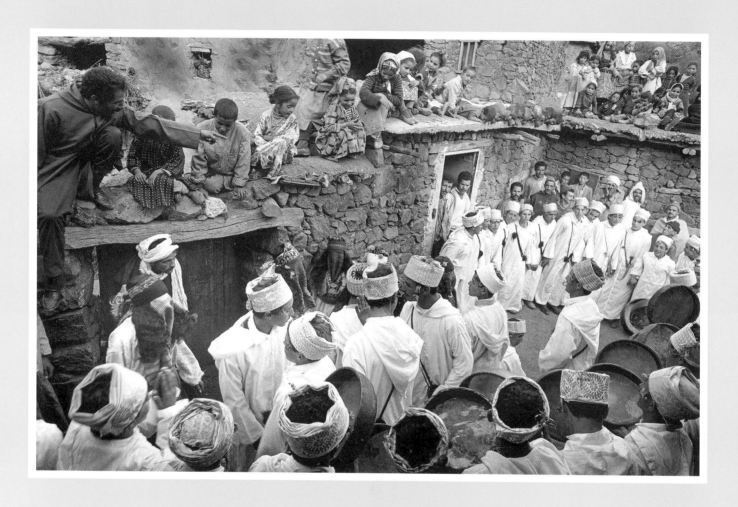

Village dances are boisterous and friendly affairs. Young men call unmarried girls to join them when their chores are over. If the dance is very crowded, any misbehaviour is punished by a hefty fine from the master of ceremonies.

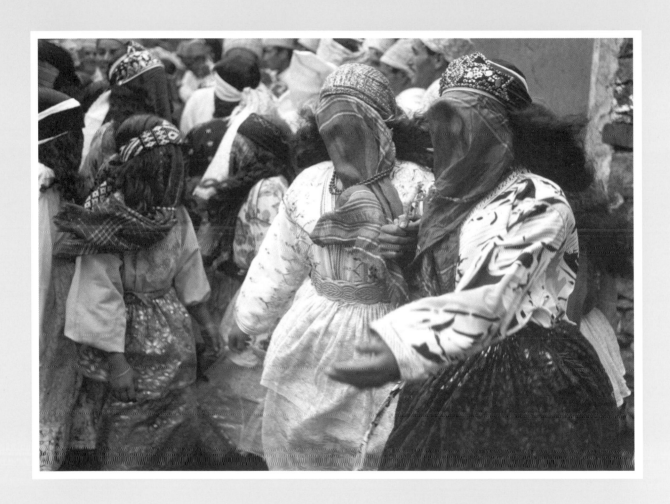

Young girls join the dance, their faces covered by red veils and their hair let loose. After dark, they remove their veils.

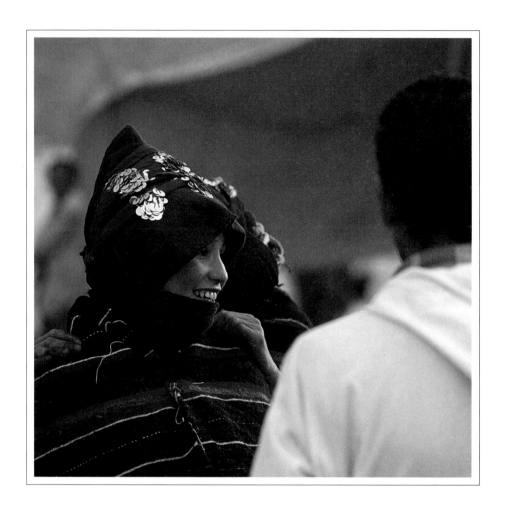

Women of the Ait Haddidou tribe, famous for their wedding festival which is held each September outside Imilchil. Unmarried virgins, visiting the festival to choose a husband, wear flat head-dresses, whereas divorced women identify themselves by wearing pointed head-dresses.

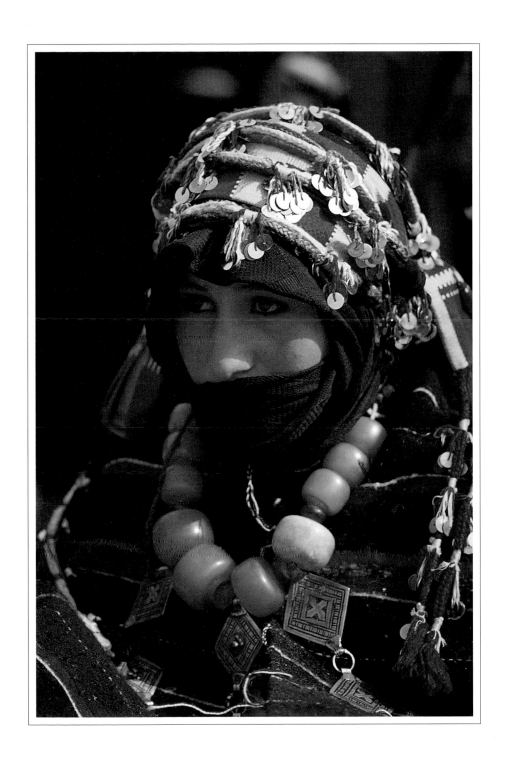

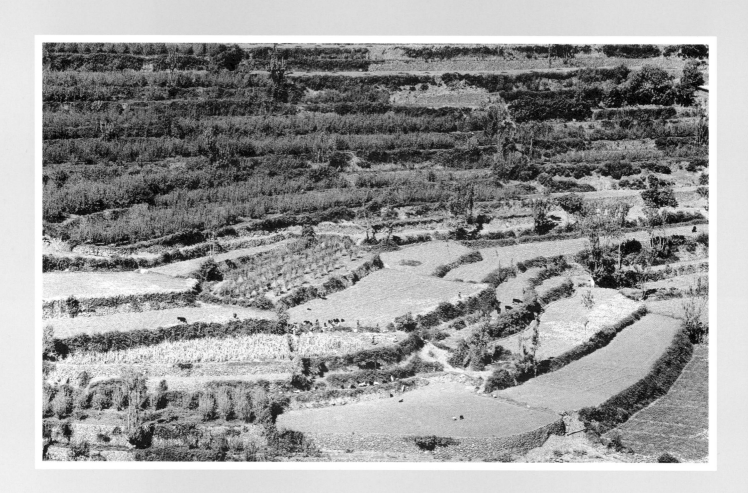

Irrigation

The mountain people have learnt to make the most of steeply sloping mountain-sides and small open areas of valley bottom. Terraces have been built up over generations to a point where, in some places, as many as eighty levels of fields can be found.

To facilitate even and regular watering of the cultivated areas, the village Berbers have developed an effective system of irrigation. They capture water from streams and channel it into ditches that run along the valley sides to the highest field levels. In a society where all land is privately owned and where water is at a premium in summer, a method of sharing out this precious commodity has evolved through necessity. Rotas to ensure village and tribal cooperation were established long ago by clan councils, and systems of communal labour to maintain and improve the common irrigation ditches (called *seguia*) are still practised today. Channels running from the main ditch feed the terraces, and each man is responsible for any ditch on or within the borders of his own land. Disputes are sorted out by the water sheriff.

Communal work is an important ingredient of life among the Berbers. Without it, irrigation and seasonal tasks such as haymaking and harvesting would be too much for individual families. In these communities, where a cash economy is still relatively new, much of village life revolves around the bartering of labour in return for the loan of a mule or a share in the yield of a crop.

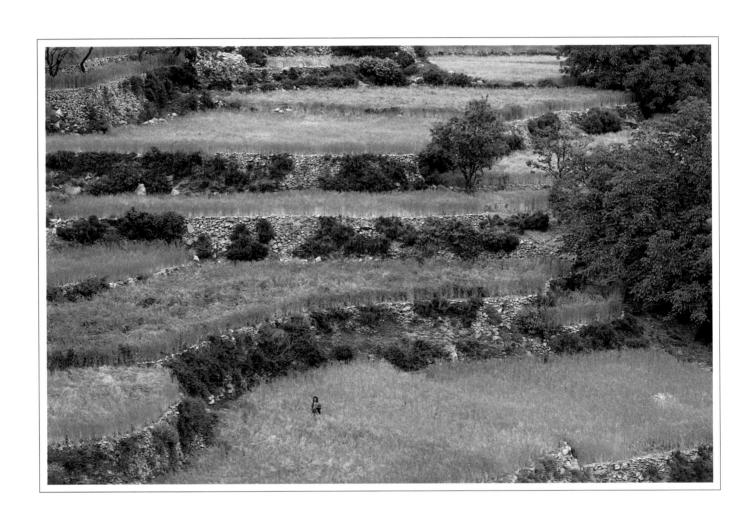

Terraces of maize.

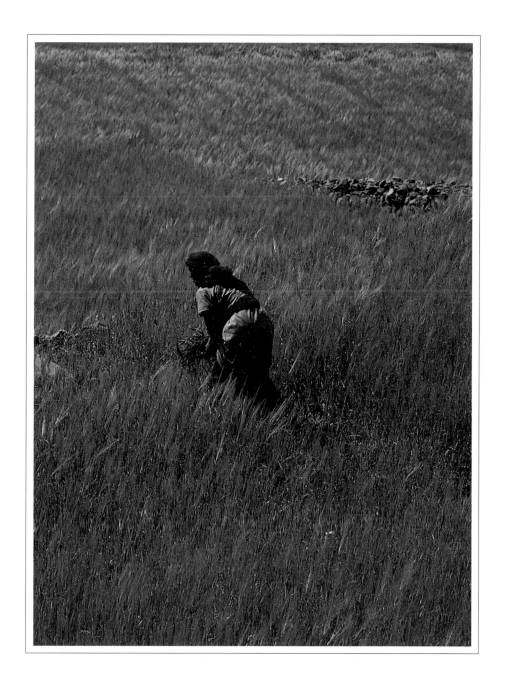

Barley.

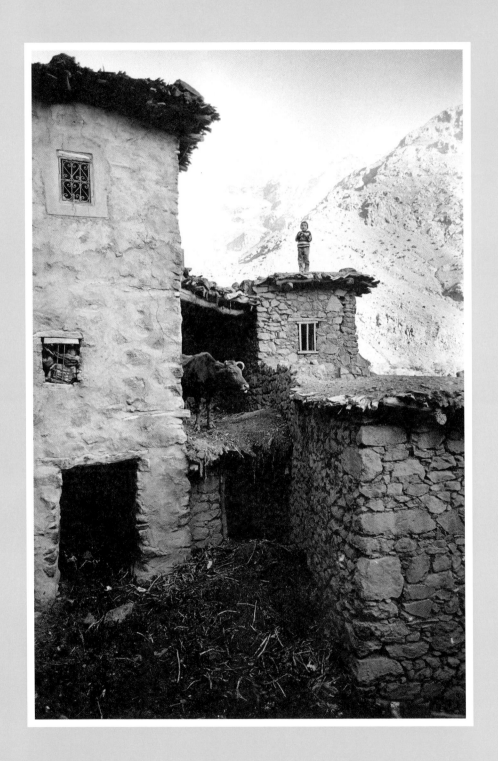

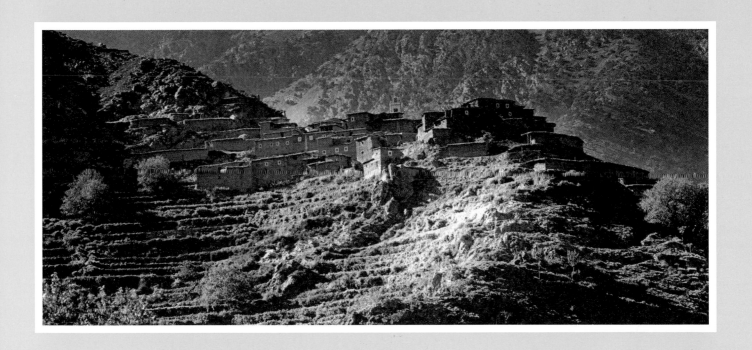

Tizi Oussem.

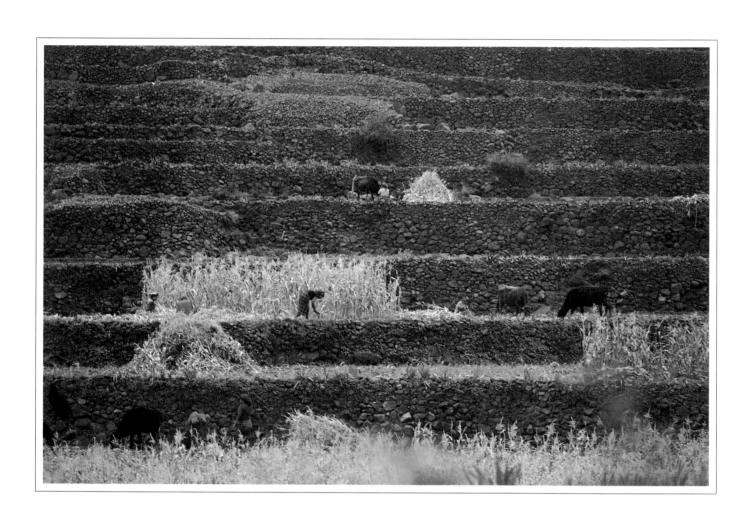

The harvest

The Berbers practise an agrarian and pastural economy that has barely changed since they first settled in the valleys of the High Atlas. On terraced fields they cultivate barley and maize as their principal subsistence crops, with potatoes, pumpkins and onions. They also grow cash crops: walnuts, almonds, cherries and, more recently, apples, which are financially very successful.

In Morocco the real summer begins in June. The air becomes a blasting furnace, the skies turn a deep blue, and midday breaks drag on until four in the afternoon. The dry rustle of the rapidly yellowing crop in the hot winds from the Sahara is the signal for the barley harvest to begin. Ideally, this should be before the corn heads ripen too much, so that as few grains as possible are lost during the cutting and transportation to the threshing floors.

The cutting of the crop is carried out in a festive atmosphere, despite being blisteringly hard work. The men use serrated hand-sickles which cannot be resharpened and so last only about three years before having to be replaced. Women and girls tie the barley into heavy bundles and carry it to the village, where it is left to finish drying before being threshed.

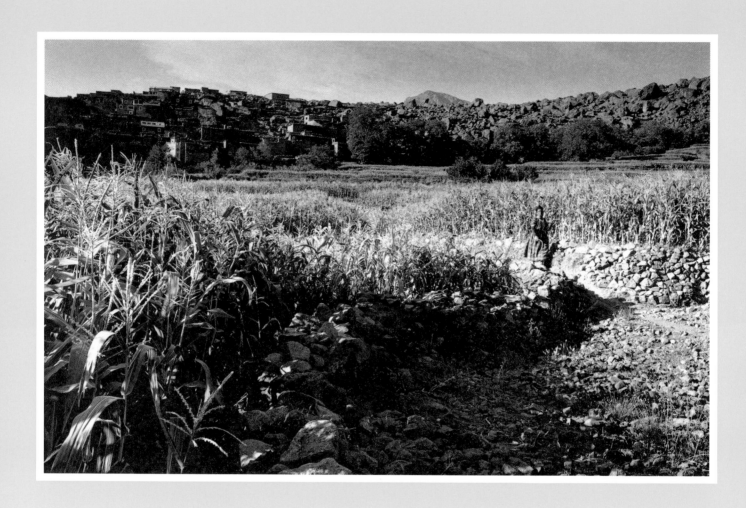

The maize crop.

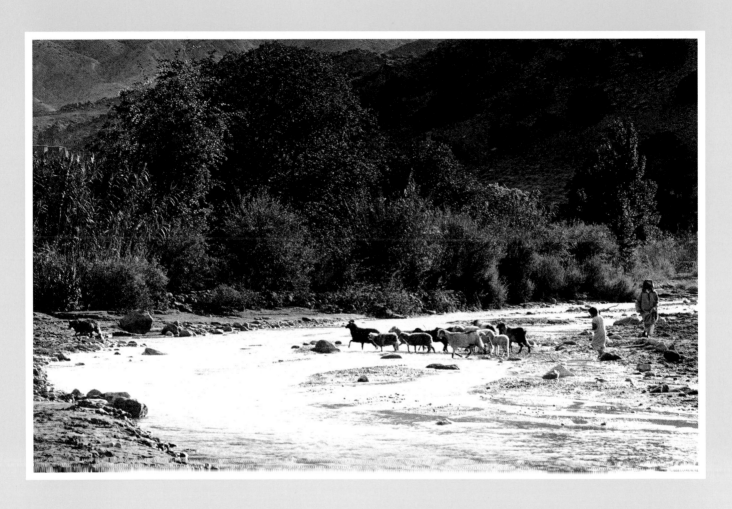

Livestock is kept in the village overnight and driven out in the mornings to pasture.

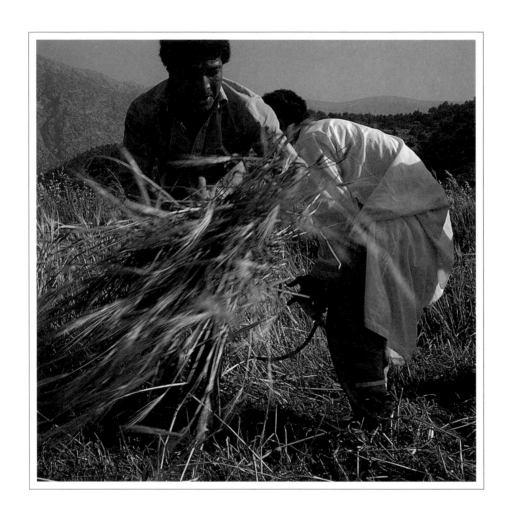

Harvesting the barley in June. Bamboo guards protect the hands from the sharp sickle-blade.

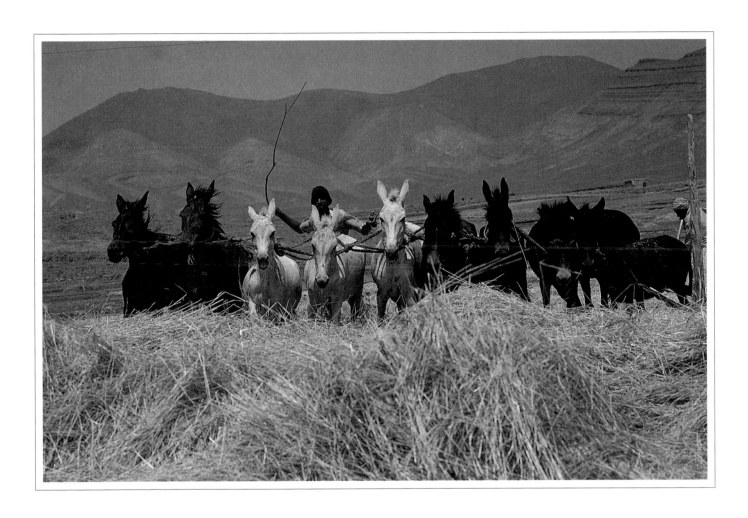

The crop is spread out on the threshing terrace around a central pivotal pole, to which a line of mules, donkeys and even cows are tied. The animals are chased around the pole, crushing the barley underfoot until it is ready for winnowing.

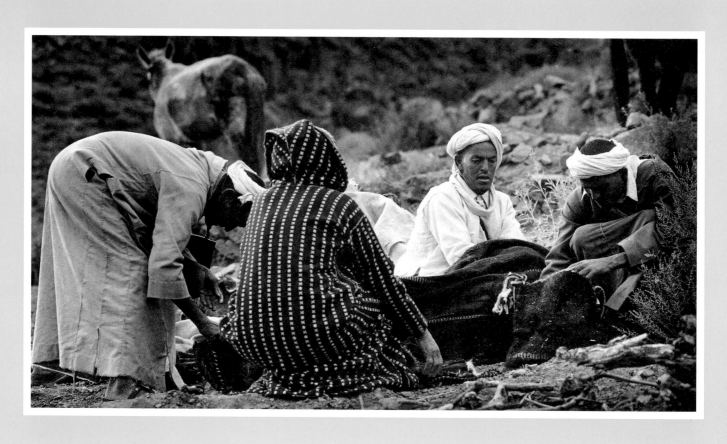

Ait Atta Berbers share out barley grain each evening for mule-feed. In the villages, each family has a supply of grain for grinding into flour and for essential feed to keep the mules healthy.

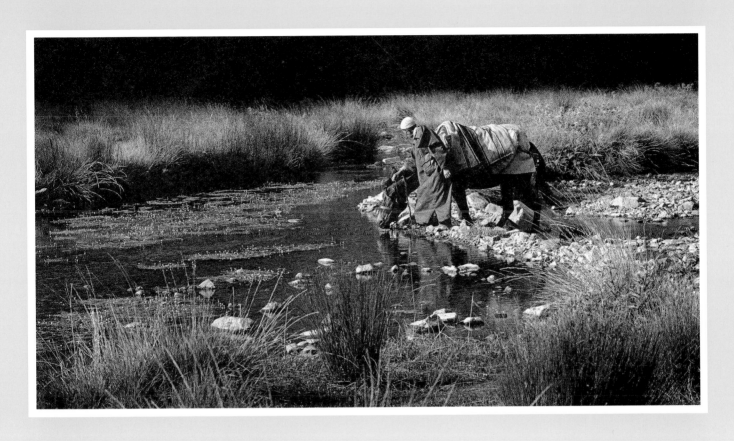

Watering mules in the High Atlas. Mules represent a huge investment, and can last thirty years. They are an essential means of transport in the mountains.

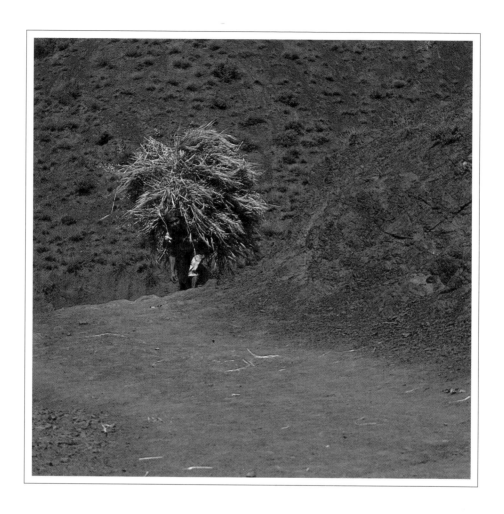

After the crop has been cut, each woman carries a bundle of between twenty and twenty-five kilograms to the village. Because it is a huge and unbalanced load, she must lean right forward. It is backbreaking and very tiring work. Stopping for a rest involves collapsing on to the load, and then only with a huge effort can the woman continue the journey.

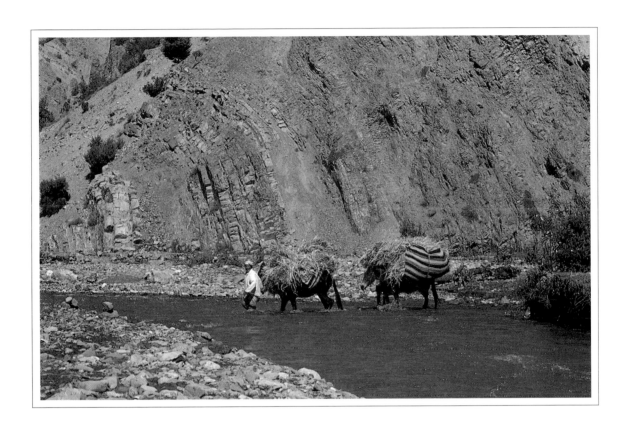

Mules and donkeys carry loads where possible, but not every family can afford one.

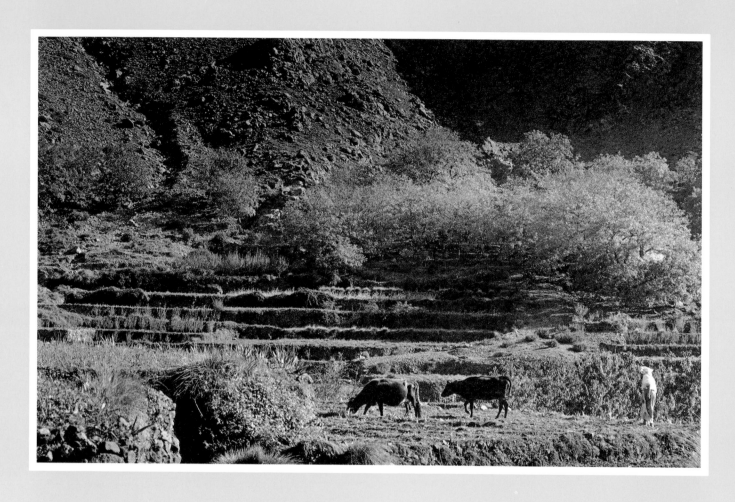

From an early age, children take an active part in helping the family to survive. Young girls help their mothers graze the cattle on the terraces, whereas young boys act as the family shepherd from the age of about fourteen. They spend their days alone on the mountain-sides and in this way learn the wider geography of their tribal lands.

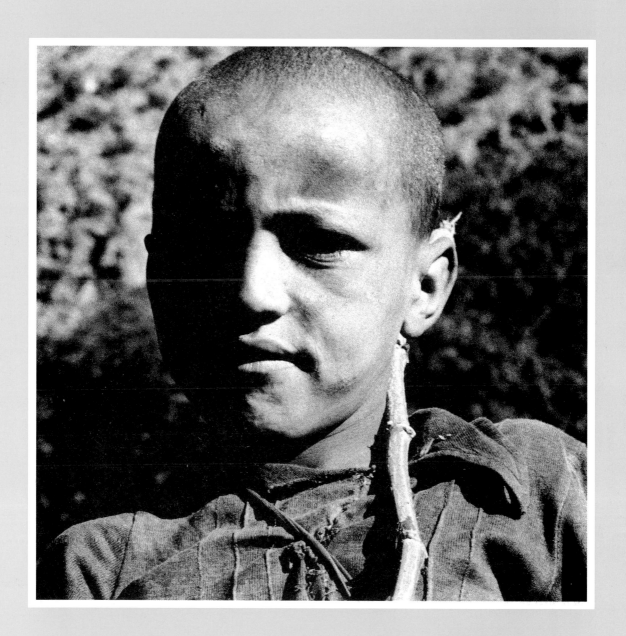

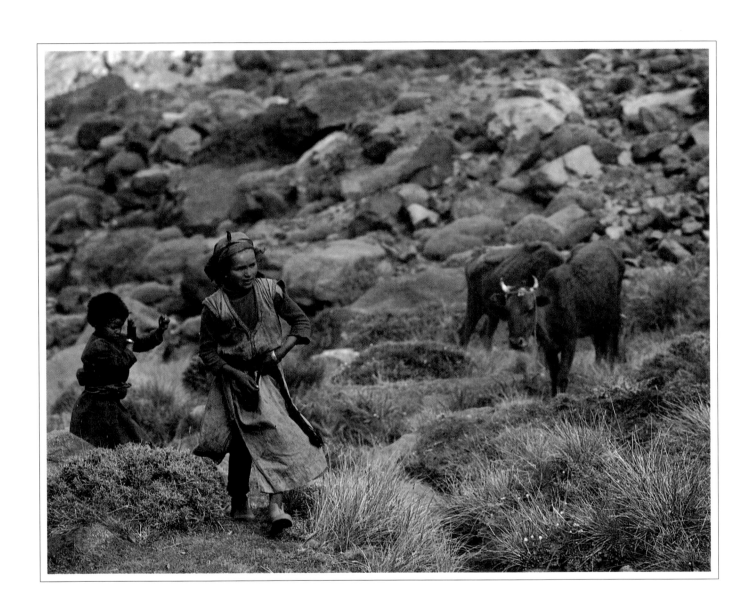

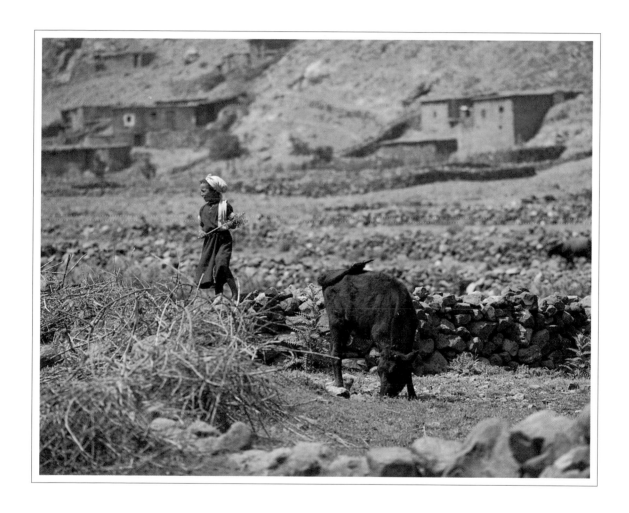

Girls look after cattle in the high summer pastures and on the stream-bed meadows.

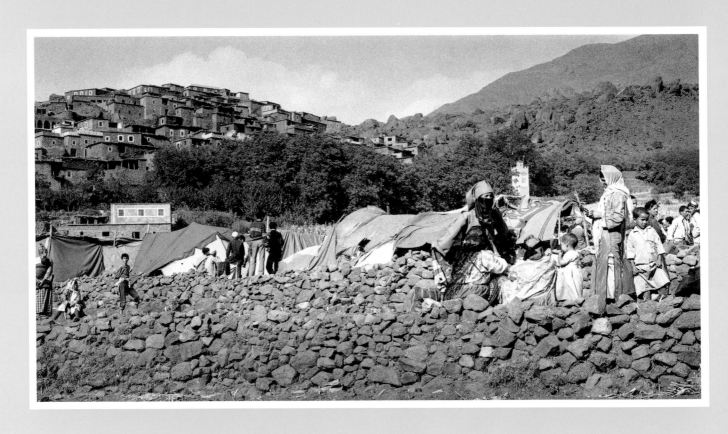

The weekly market or souk *provides what the Berbers cannot grow or make themselves. It is also important for exchange of news, and is often the only time when the nomads come into contact with the outside world.*

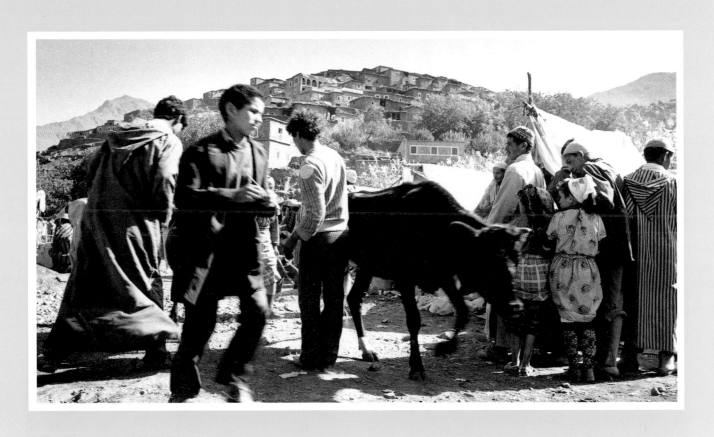

The Moroccan government relies on the souk *to maintain its control over the tribes, sending police and other officials to enforce the law and collect taxes.*

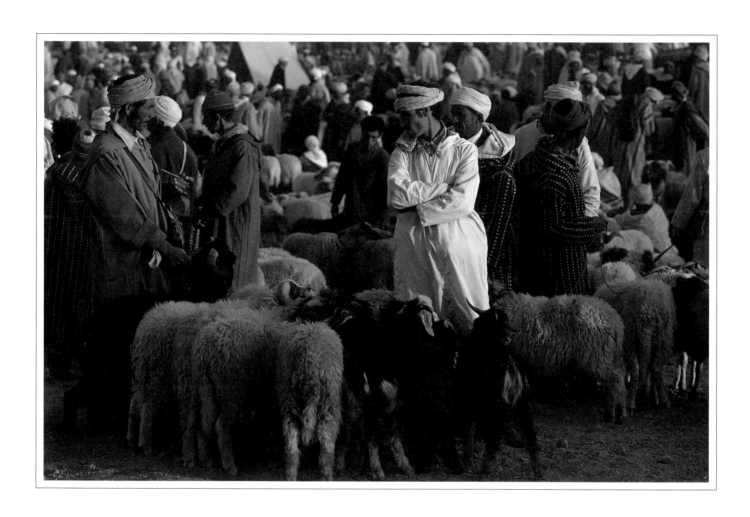

The livestock market at Imilchil.

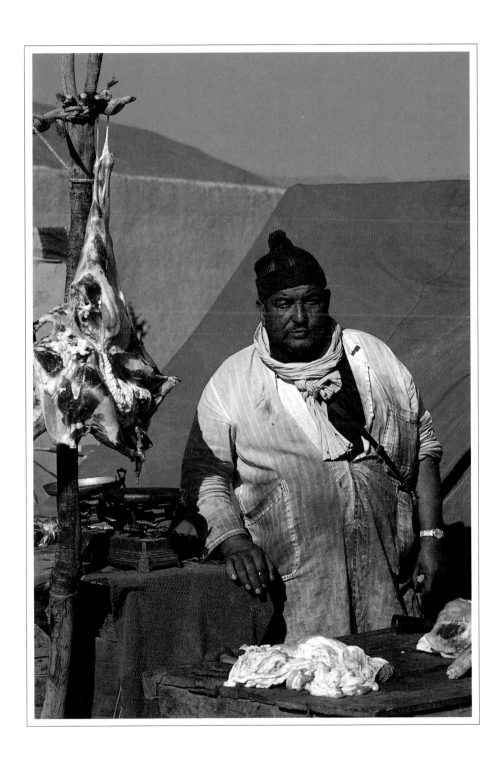

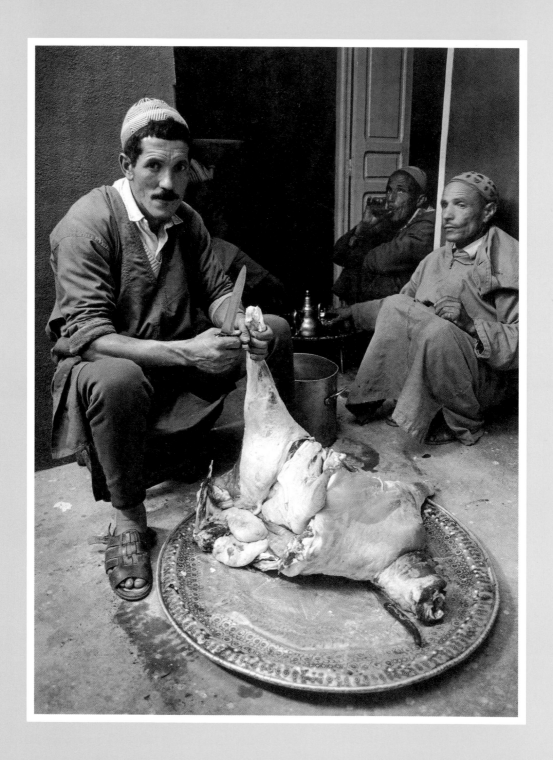

Preparing meat

Meat is the most important ingredient in Berber cooking, although few households can afford to eat it daily. Special occasions require the slaughter of an animal for the feast served to honour guests. All Berber men are accomplished cooks and take an active part in preparing special feasts. Women do not slaughter animals. If there are no men present, a small child, even a baby boy, holds the knife while his mother helps him to slaughter the animal.

The nomads are expert butchers. They can kill a sheep and cut it into joints in fifteen minutes with the minimum of wastage. To ensure that it is *halal* (or socially and religiously acceptable), the animal must bleed to death.

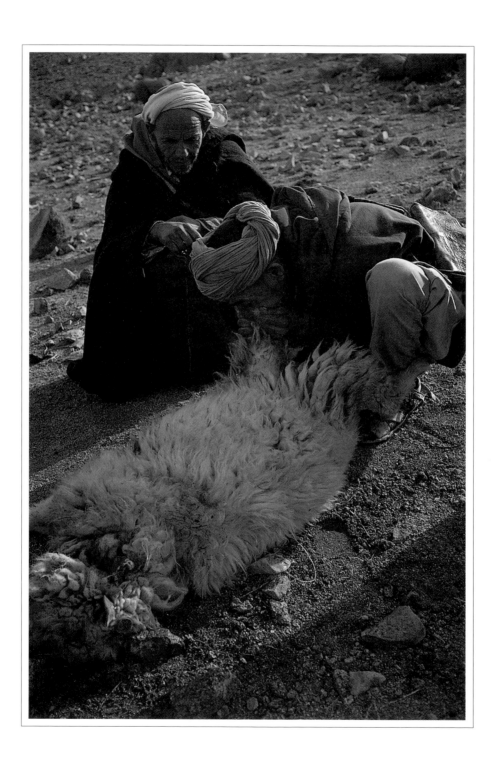

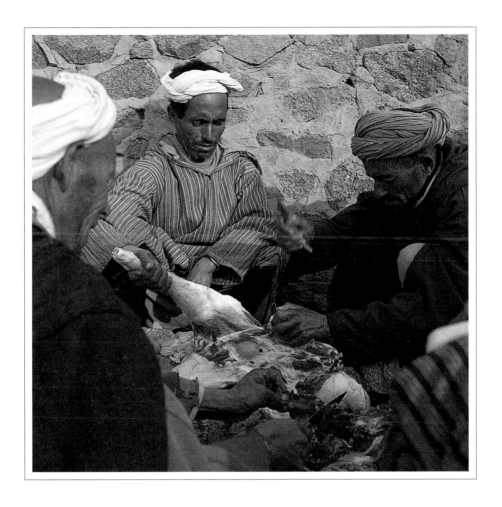

Nomads skin a sheep by blowing through incisions in its fleece at the hind legs and then removing it in one piece. Once butchered, there is a use and often a special dish for all the meat and every organ.

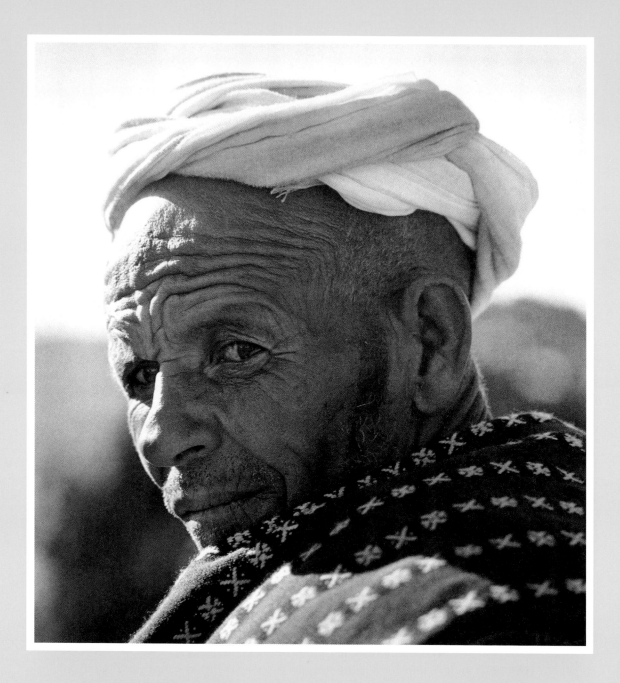

Alilouch ibn Zaid has lived in a tent all his life. He has two wives — the youngest, Sara, is not much older than twenty — and three children. Men often marry a second, younger wife who takes on the hard work, leaving the first wife free to 'retire'.

The nomads

The nomadic Ait Atta Berbers spend the winter in the valleys of the Gebel Sahro and on the semi-arid plains around the Draa valley. During the summer, they move higher into the mountains and sometimes migrate into the Central Atlas where they have traditional grazing rights.

The nomads live in goat-hair tents with a single ridge dividing the women's quarters and the entertaining area. The kitchen is a small enclosure built at the front of the tent. Around the camp, other enclosures house the family's sheep, goats and mule. Family possessions consist of traditional copper or earthenware pots, a steamer for *couscous* (a dish made from cracked wheat and chickpea flour), kettles and teapots, bundles of clothes, blankets and a few rugs. The camp is fiercely guarded by dogs kept to protect the animals from jackals.

The Ait Atta are one of the toughest of the Berber tribes. They held out longest against French colonialism, surrendering only in the 1930s at the battle of Bou Gafer.

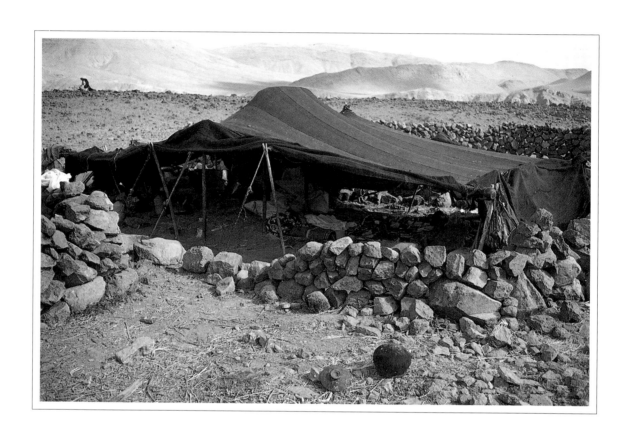

Segregation among the Ait Atta is very informal, and the dividing curtain is often left open.

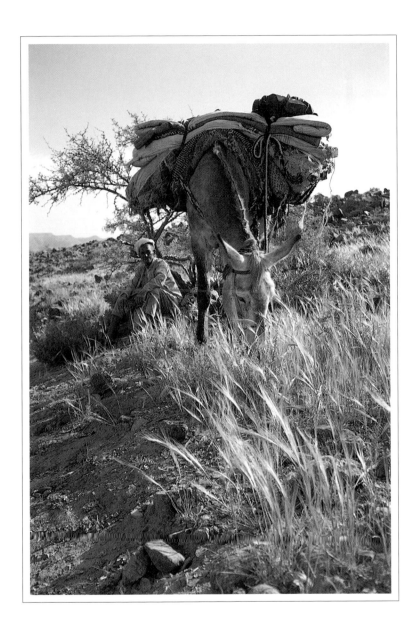

Spring in the Gebel Sahro produces a brief period of plenty, and nomads move to good pasture. Wild grass, called hashish, *provides excellent grazing.*

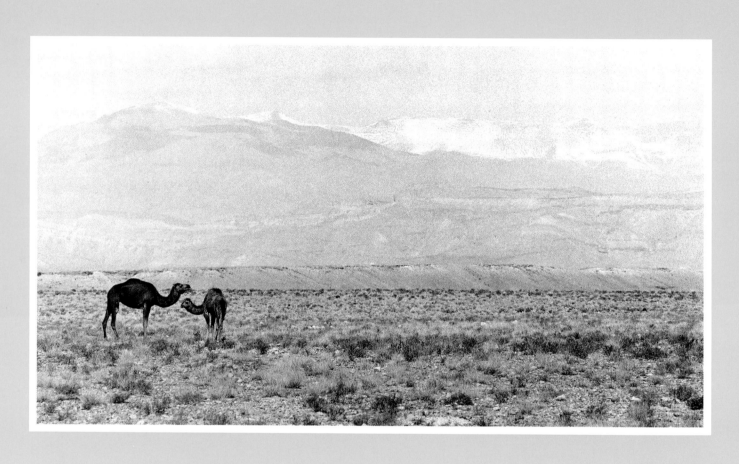

Camels are popular pack-animals among the Ait Atta and, unlike the mules which are brought in from the plains, are bred by the nomads.

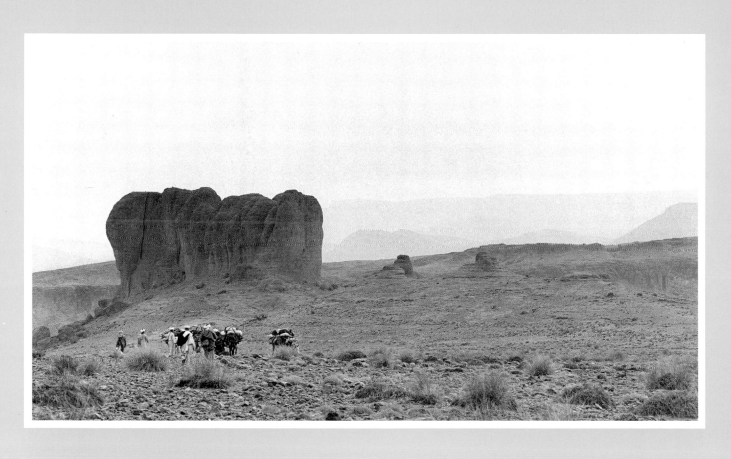

Dramatic rock formations in the plains between the Gebel Sahra and the High Atlas.

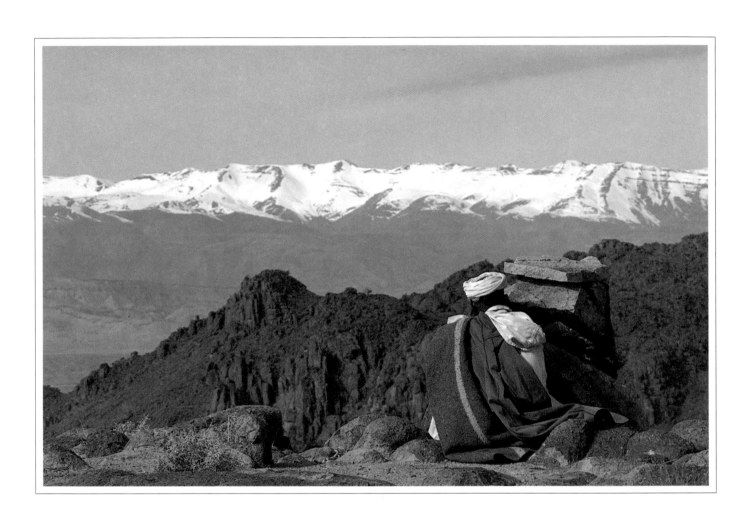

In the clear air of midwinter, a nomad looks towards Gebel M'Goun in the Central Atlas.

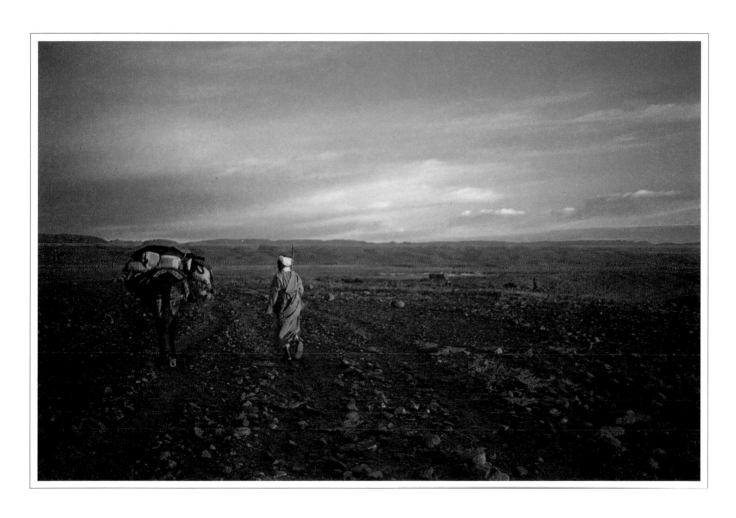

A nomad heads back towards the mountains after visiting the weekly souk *for news and supplies.*

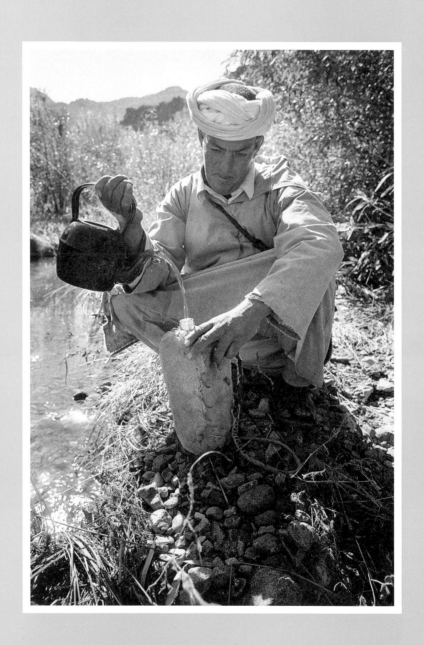

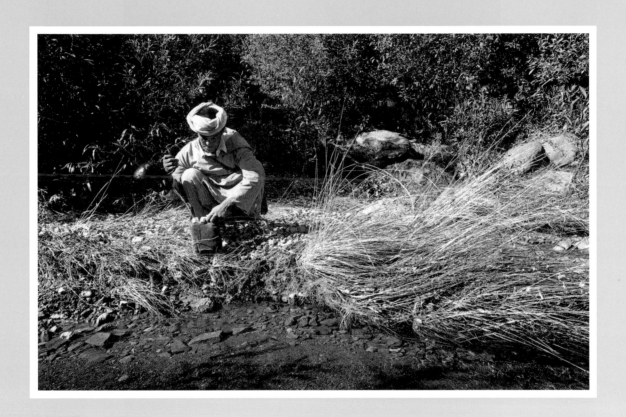

Collecting water.

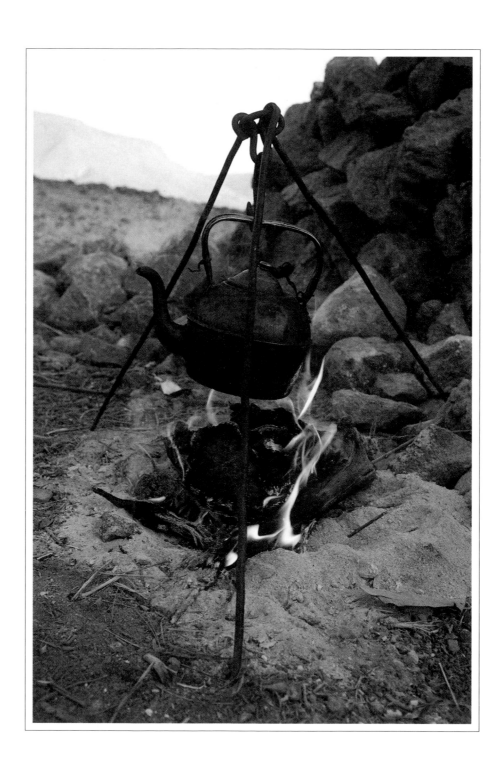

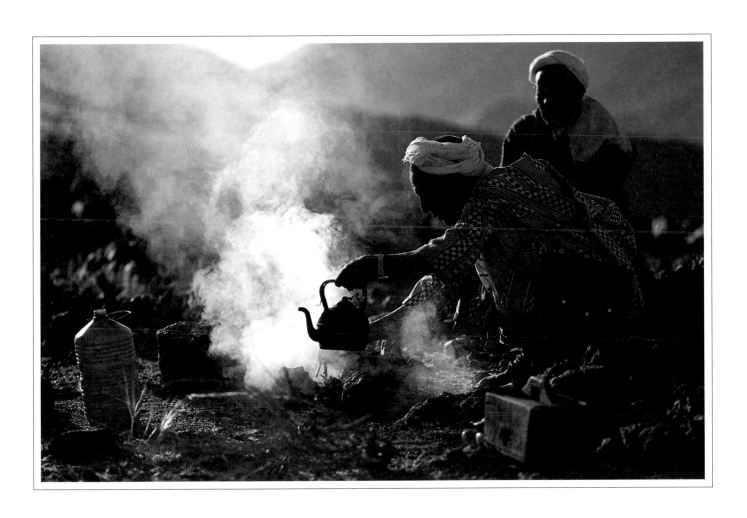

Nomads making mint tea, which is drunk very sweet.

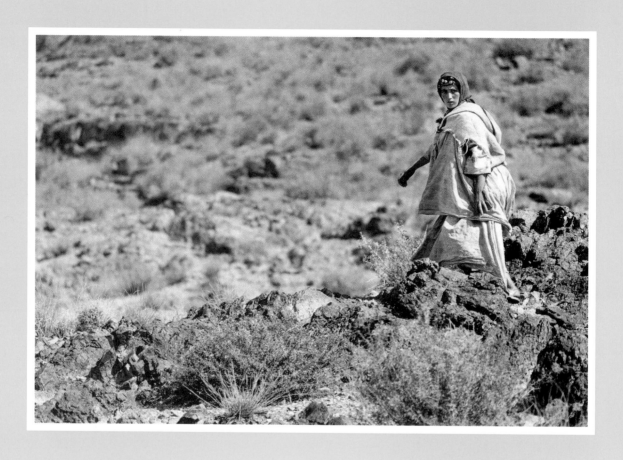

Nomadic women cover their brightly-coloured dresses with plain shawls pinned at the shoulders with brass or silver brooches. Their head-dresses, which differ from those of the women of the High Atlas, are often heavily embroidered and trimmed with colourful bobbles.

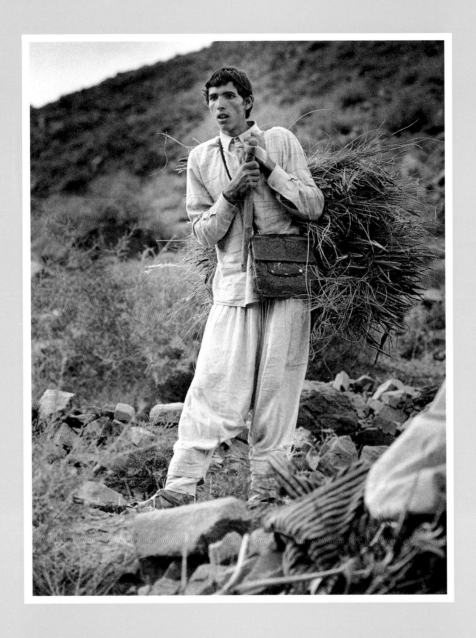

When travelling, the needs of the mules always take priority over those of their owners.
Nomads will walk great distances to gather fodder for their animals before collecting
their own firewood and water.

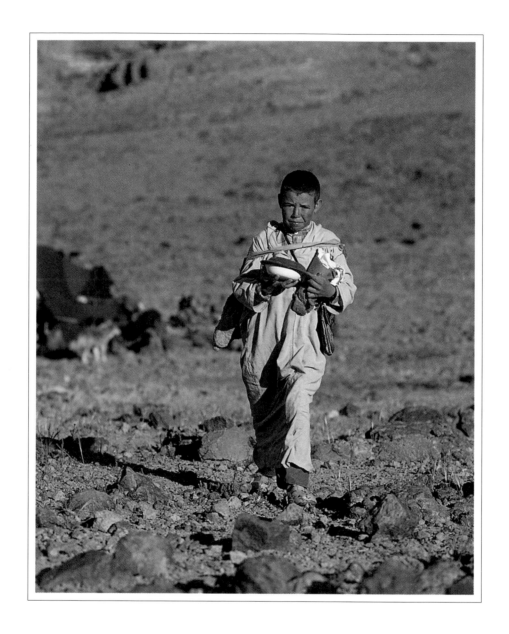

The family shepherd carrying a sugar loaf. It is customary for guests to bring gifts of sugar when visiting friends.

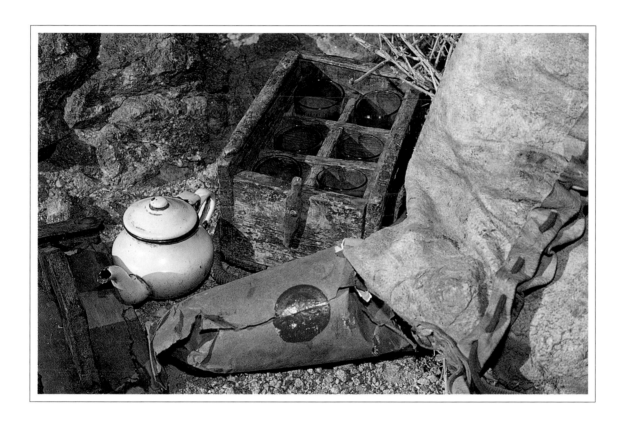

The essential tea kit. For the nomads, constantly on the move, care is taken to keep everything safe from damage. Glasses are kept in a special box, teapots carefully wrapped in cloth, and the green tea and mint carried in a goatskin bag.

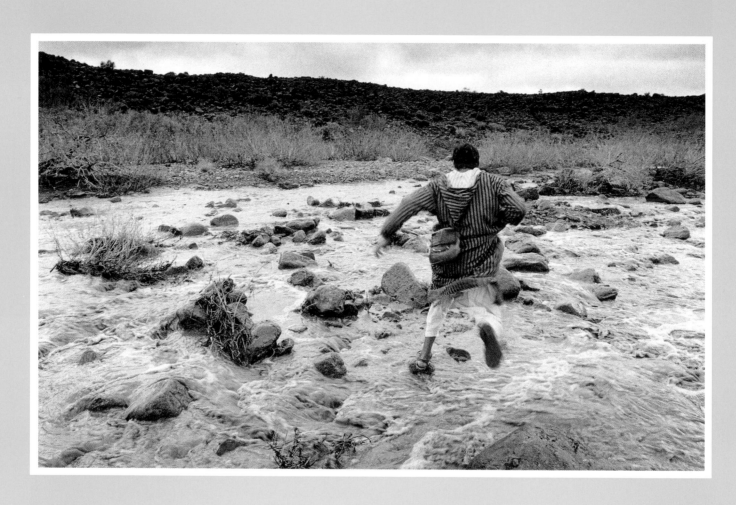

Seasonal rain causes flash floods and temporary rivers which appear and disappear within hours. They can cause great destruction and sweep away surprised men and animals.

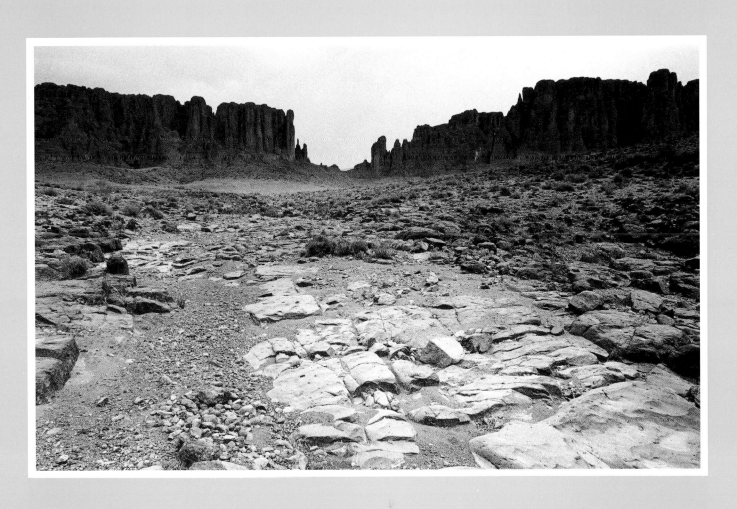

Tadaout n'Tablah, in the Gebel Sahro, a spectacular table-top of sandstone pillars forming one of the most remarkable features of the mountains.

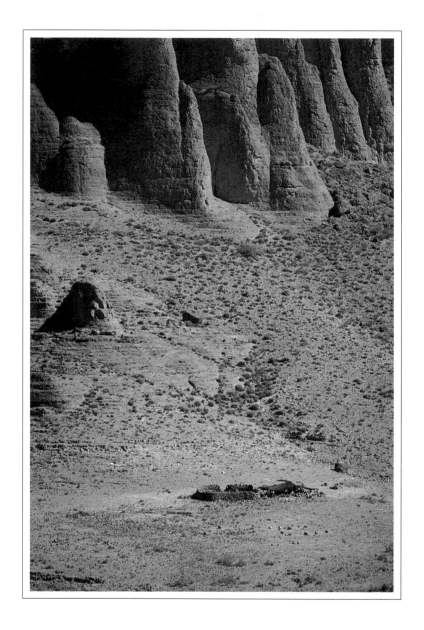

A nomadic encampment is dwarfed by the pillars of Tadaout n'Tablah.

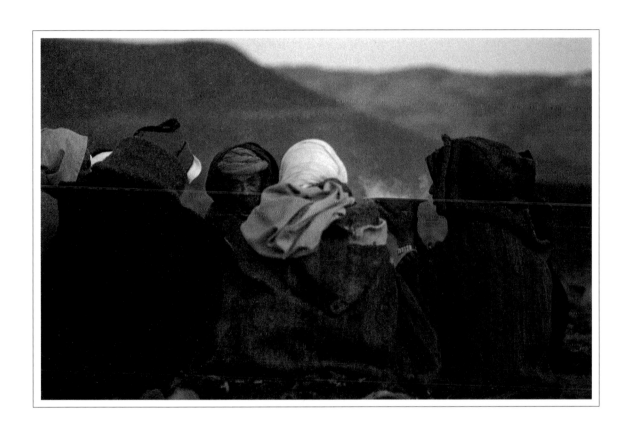

Breakfast in winter is a soup made from maize and barley flour, salt and pepper.

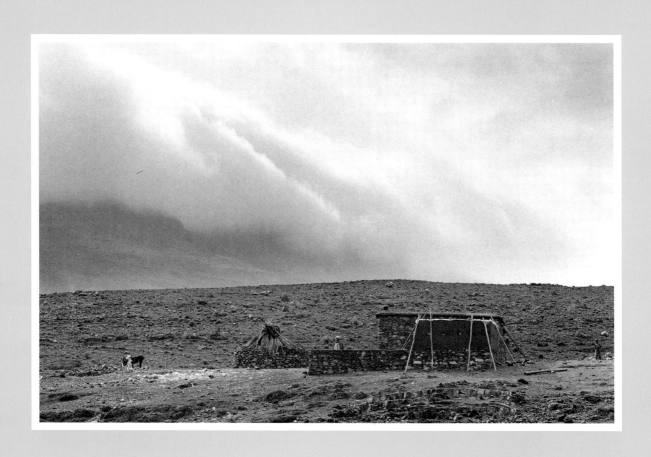

An isolated farm in a valley of the Gebel Sahro.

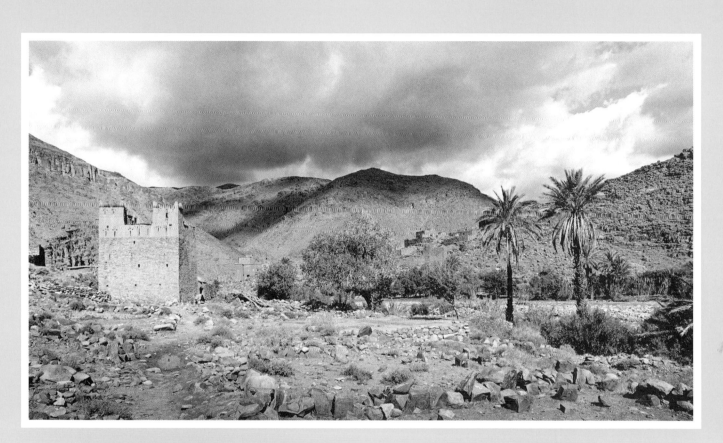

In the large valleys with permanent rivers, small villages have grown up. Here, water provides sufficient irrigation for gardens growing almonds, dates and figs as well as the usual barley and vegetables. The old kasbah *is still used for storing grain.*

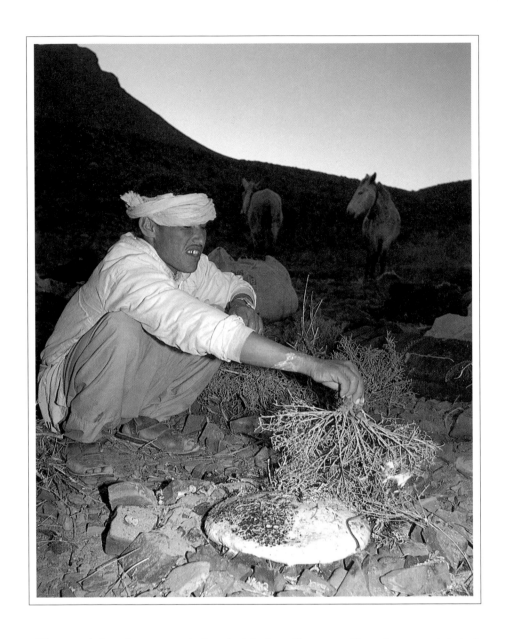

The nomads have learnt to make bread with virtually no utensils and no oven. A bed of stones is heated and then the dough is placed on top and sealed with burning twigs.

The dough is covered with more stones and a second fire is built on top to bake the bread.
The finished loaf is smooth on top and pitted underneath.

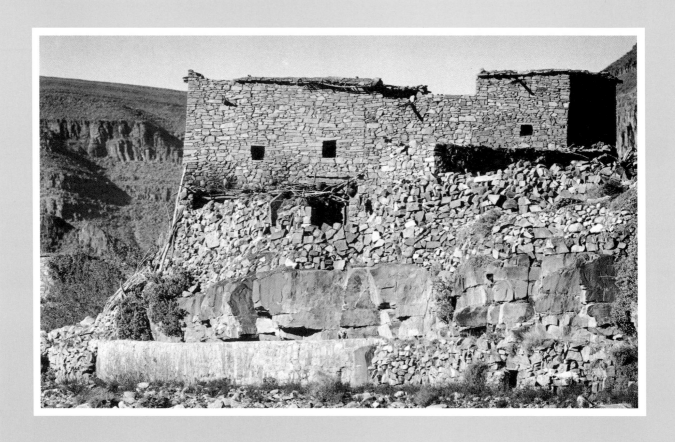

Houses in the Gebel Sahro are enclosed and featureless, and built of dry stone. They are designed for protection against the heat and against jackals that would otherwise prey on the family's livestock.

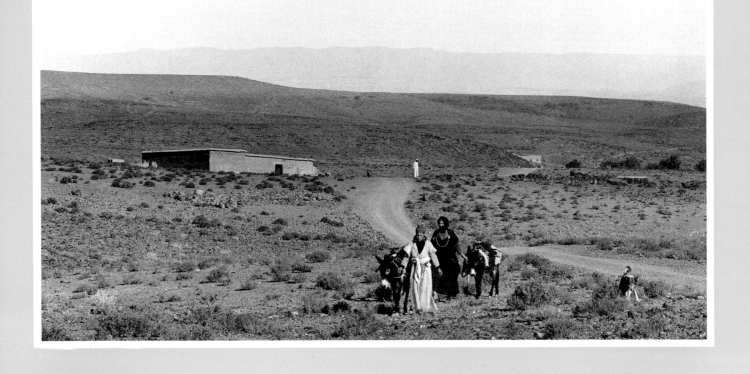

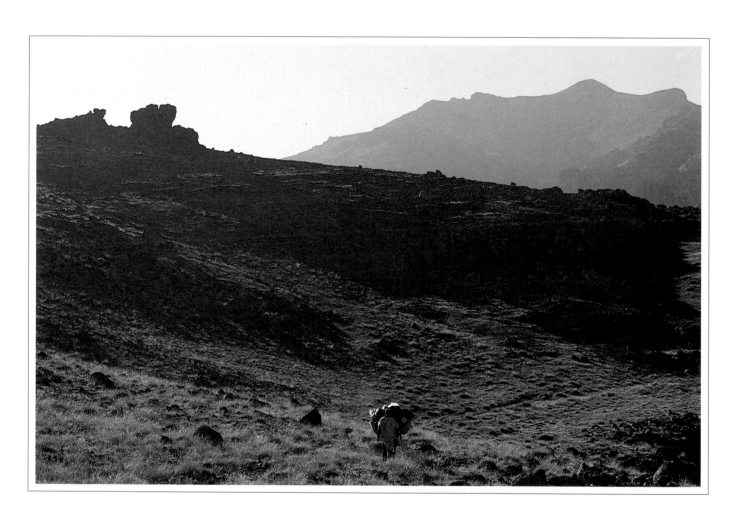

*My constant companion in the High Atlas, Mohammed Ben Brahim, is travelling here
with his mule across the high plateau of the Gebel Siroua. He was the first from his
village in the Ait Mizane to travel so far, and the trek became as much an adventure
into new territory for him as it was for me.*

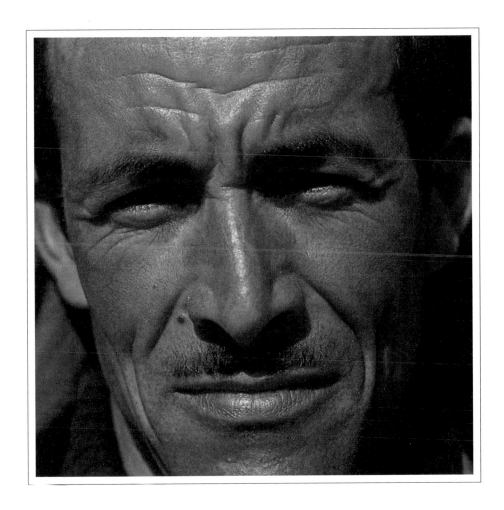

Throughout the travels which produced this book, I came to know many people as individuals and some as close friends. All of them had characters and lifestyles of an admirable quality. This book is about them as real people rather than as subjects seen through a camera lens. The Berbers are a race of dignity and culture who demand great respect.

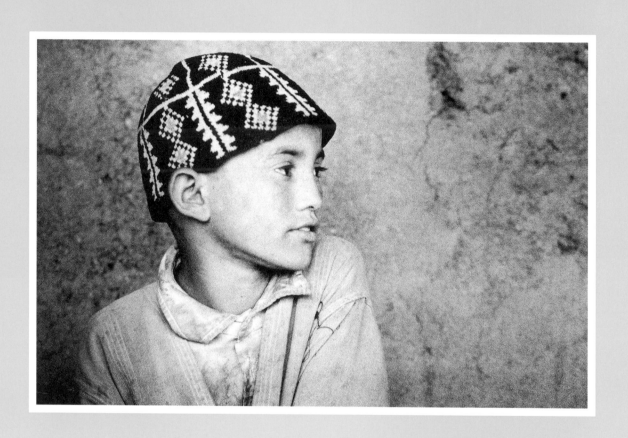

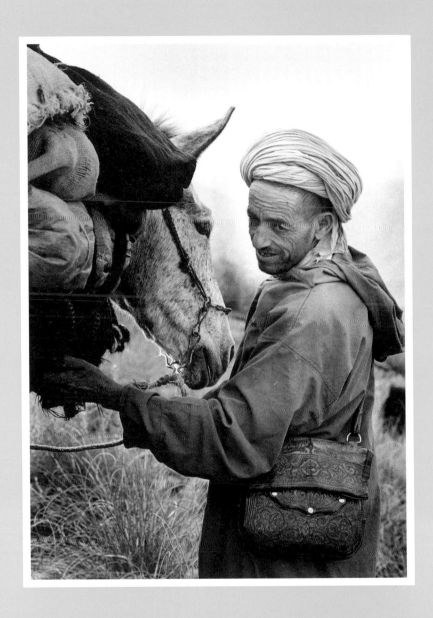

Addi is typical of the Ait Atta Berbers. Constantly in good humour, he has great dignity and gentleness. However, his soft 'great-uncle' personality is tempered by the physical hardness common to all nomads. Living with the minimum of comforts, he survives the blistering heat of summer and the bitter cold of winter when even the sand seems to freeze. A nomad's satchel contains all his personal belongings: identity papers, photographs, knife, spoon, glass, string, tin of sardines ...

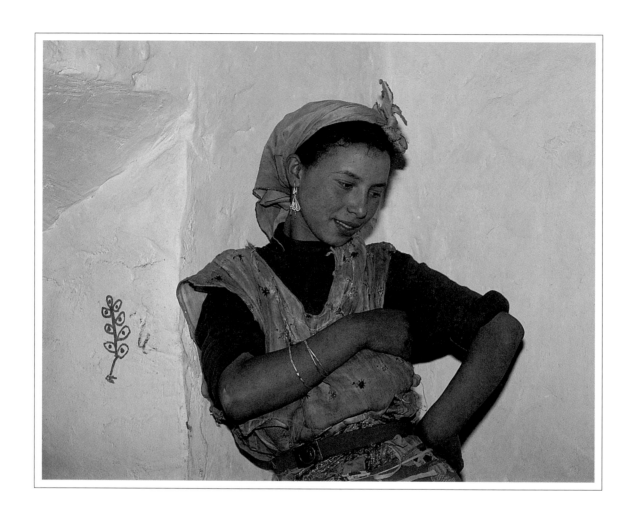

Malika is seventeen and lives with her widowed mother and fourteen-year-old brother,
Mohammed. She virtually runs the family home, collecting water and firewood, grazing
the cows and goats, while Mohammed works for other members of the tribe in return for
a share of their crops.

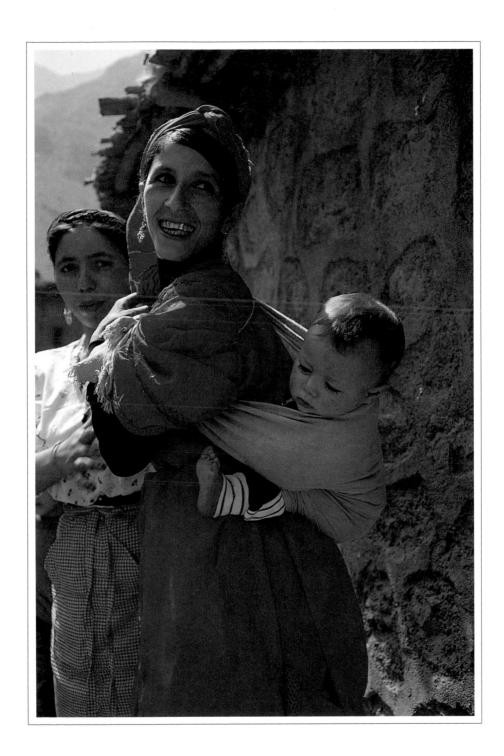

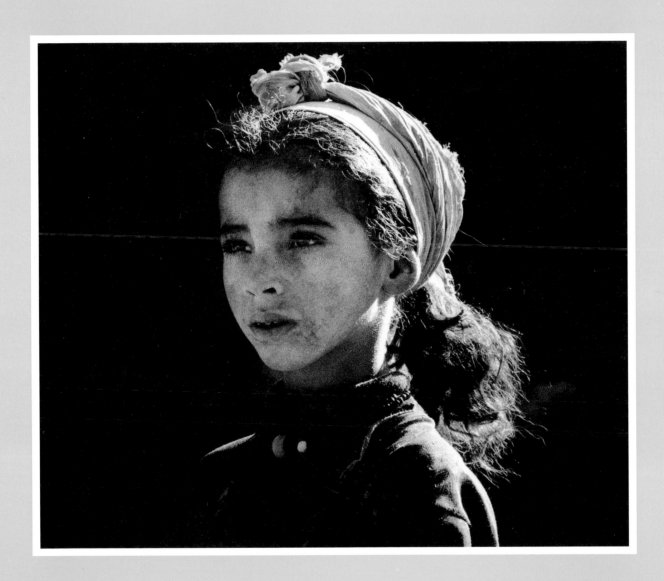

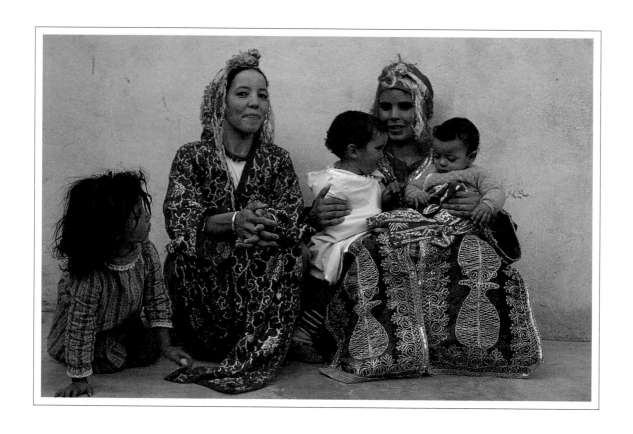

Two Berber women of the Ait Mizane pose with their young sons. Children, especially boys, are the joy of a Berber's life, ensuring the all-important continuation of the clan.

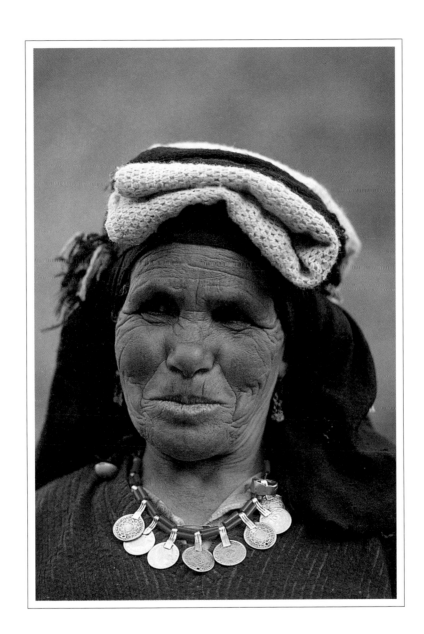

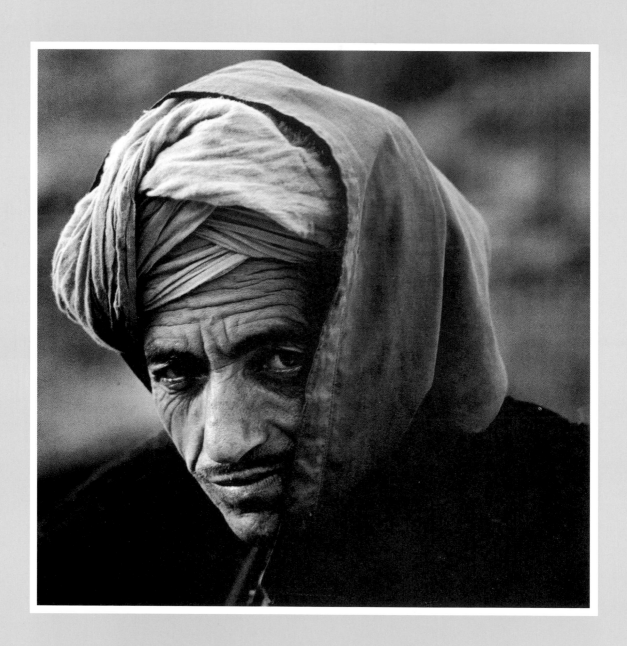